A Child is Born

6 months, approximately 30 cm.

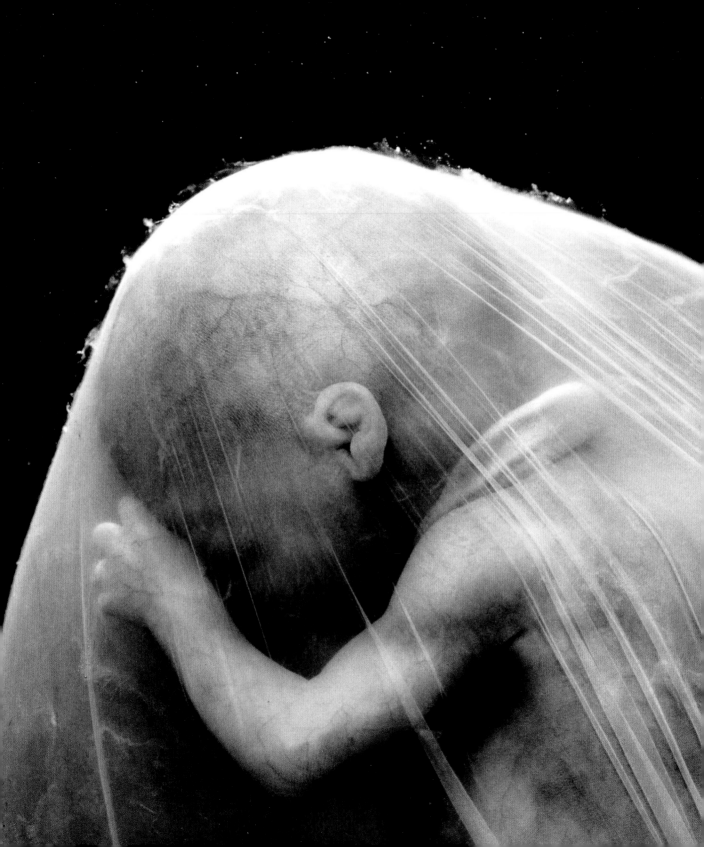

A Child is Born

LENNART NILSSON

JONATHAN CAPE, LONDON

TEXT BY LARS HAMBERGER

The egg surrounded by sperm.

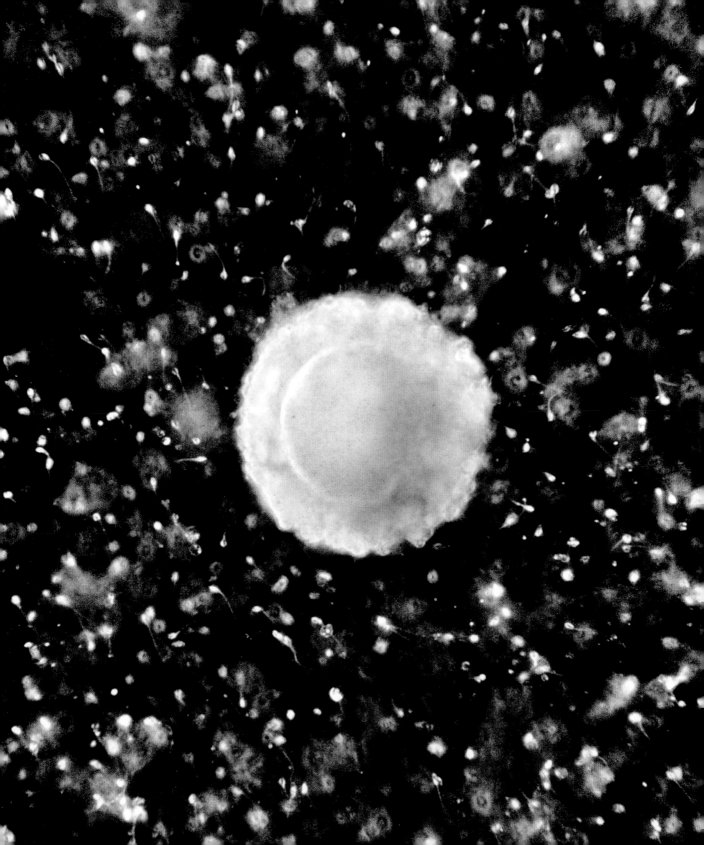

6 weeks approximately 11 mm.

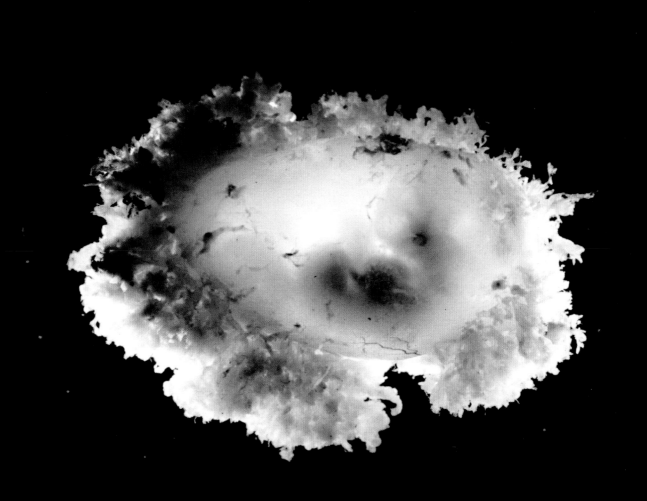

13 weeks approximately 50 mm.

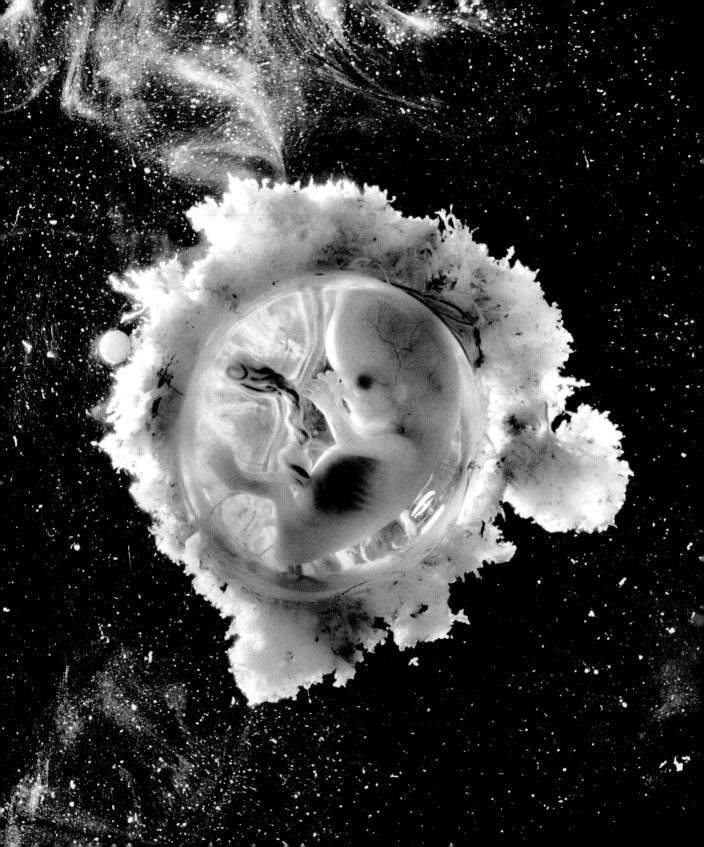

20 weeks approximately 20 cm.

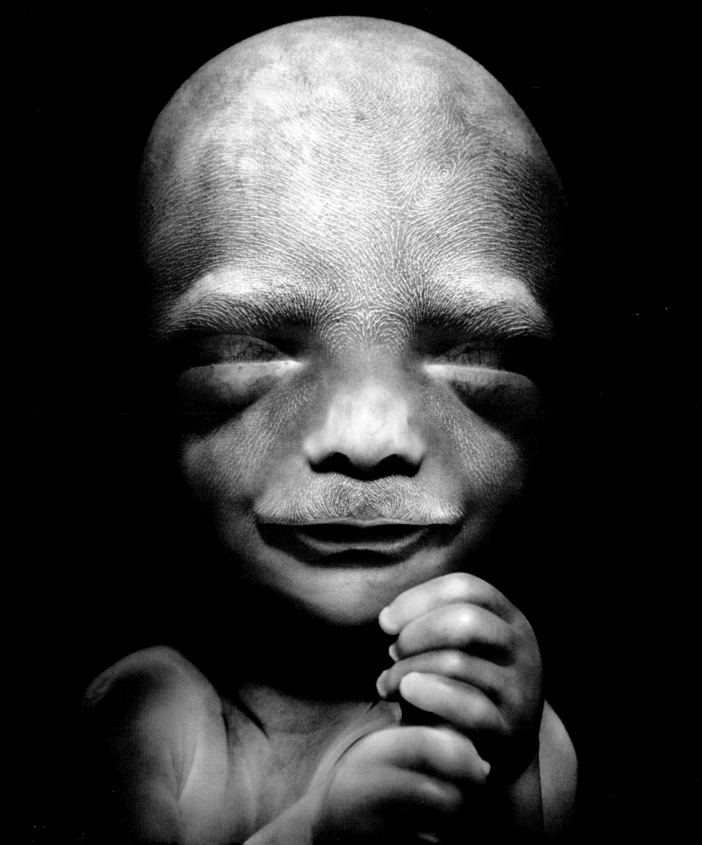

Introduction

BY MARK HOLBORN

YOU CAN OPEN THIS BOOK as you would a box of wonders or some childhood treasures. It is a depository of human knowledge. Although the book includes some of the most frequently published photographs in history, the pictures retain the power to transfix us. We can still look at them as if discovering them for the first time, like re-reading a book from childhood and returning to a childhood imagination. These photographs offer explanations, yet they continue to inspire awe and mystery. Unlike a hoard of specimens with shells and fossils of extraordinary age, they reveal a different kind of evidence. These pictures are of us.

When this book was first published in 1965, Lennart Nilsson had that very year stunned the world with the first photographs of prenatal life. Then, less than half a century ago, the world was so different. Even though we were coming to terms with the knowledge of possible self-destruction through human ingenuity with the atom, there was optimism that science could save us. Even though the political landscape was clouded, we were hopeful that a new generation would cross the political barriers. We could recognise our common humanity, regardless of manmade boundaries. We were the inheritors of the "family of man". Lennart's pictures remind us we are all born from a common process, we are all the outcome of the same interior encounter and we all share the same emotions that drive us to seek or offer the protection of the parent.

The photographs would not have their power to astonish us were they simply data as cold as laboratory information. They operate at altogether another level of human signal and response. The unborn child in the last stages of the pregnancy, its human features fully recognizable, is as beautifully photographed by Lennart as the newborn was once painted by Renaissance masters in the arms of the Madonna. The photographs can touch a deep emotion – a universal emotion.

Four years after the first publication of the book, men landed on the Moon. The overriding experience of those who made the epic journey was that they saw the Earth in a new way. They had literally stepped not just on to lunar dust but outside of their usual selves. The most popular photograph from the thousands they made is the picture of the Earthrise. In that image we see our place of origin in the context of space. You can marvel at the power of Lennart's photographs, which were produced in a century whose history was measured by photography. You can wonder at what was revealed by the lens, but in fact you face a reflection. When NASA followed the Apollo lunar enterprise with the Voyager missions that probed deeper into space, they took on board an image by Lennart of a human foetus. The photograph was a token that stated "this is us".

Lennart is a storyteller. His background as a photojournalist accounts for his sense of narrative. He is a populist who has made invisible worlds accessible beyond the realm of scientists. This story of a sperm and an egg–of the junction between male and female–is unsurpassable. Its conclusion is a new life. But how the story is told has changed over the years. The first edition was predominantly illustrated with black and white photographs. Photojournalism in the mid-sixties, like television reportage, with a few exceptions was almost entirely black and white. Subsequent editions were emphatically in colour and a more expansive text by Lars Hamberger was added. The book became a standard guide not only for mothers-to-be to appreciate the changes their bodies were undergoing, but the book served as a reference for the postnatal period. The Internet did not yet exist. The abundance of information from the web was less directly available.

We now inhabit an interactive world, where stories are read differently. The balance between the word and the picture has changed. Perhaps we have become more visual at the expense of language. The presence of photographs in our press, on our

streets and on our walls reflects a shift. The screen has become the central focus of the domestic interior. Rather like a preliterate society that understood essential narratives through wall paintings or carvings, we read picture sequences as easily as we watch film. The word is often secondary to the story. We absorb the picture before we refer to its caption.

Our challenge has been to redefine this great book for a new age. This is a logical development in the book's history. We have gone back to the photographs afresh, even including some of Lennart's remarkable early black and white work, and reconfigured the sequence. Our task has been one of reduction, not expansion. We have attempted to re-tell the story but with the photographs as the dominant driving force of the narrative. Lars Hamberger's new text follows the pictures. The reader, in whatever country and at whatever age, can see Lennart's photographs freed from the weight of surrounding columns of language and then refer to the caption or the text where the events of the story will be explained in detail. Although the narrative has one direction, the reader can move through this book, turning the pages backwards and forwards as is needed.

Since Lennart broke the ground in this field, there have never been photographs that possessed the same quality. Techniques have advanced. The scanned imagery of the human embryo is getting sharper. Colour can be digitally imposed. We are approaching the age of three-dimensional imagery that will only exist on a computer screen. But Lennart's work has a unique ingredient, which is why this book has appeared in so many languages and editions. It is accessible to the parent and the child alike. These photographs are clearly of a time, but like great art they possess timelessness. They have their own pulse, one of profound discovery, for, of course, Lennart is more than a photojournalist, and this is much more than a simple story.

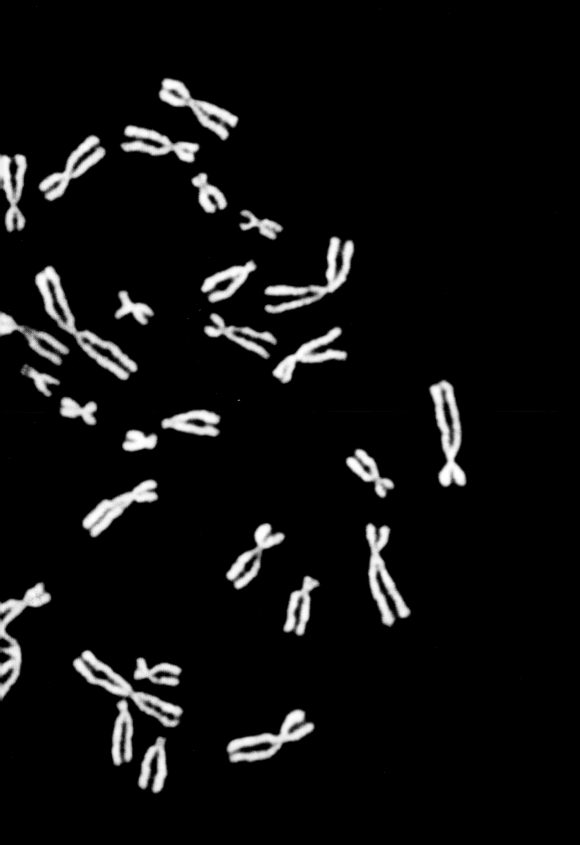

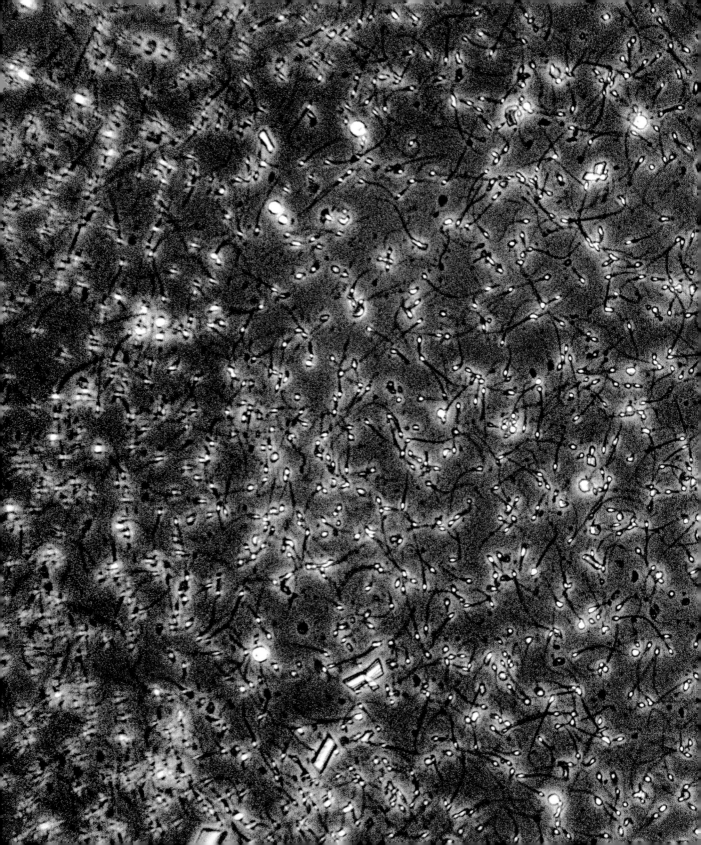

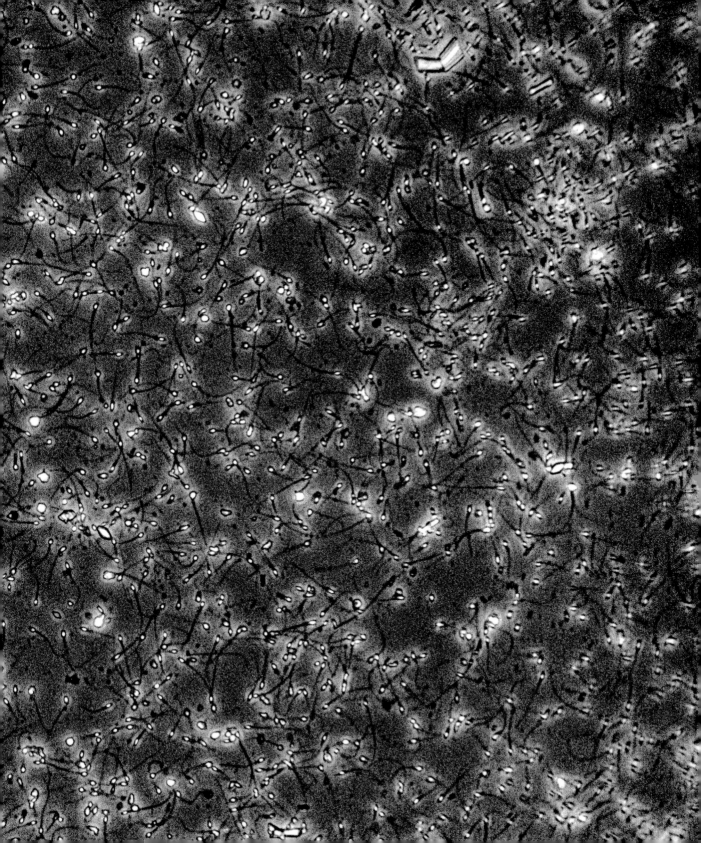

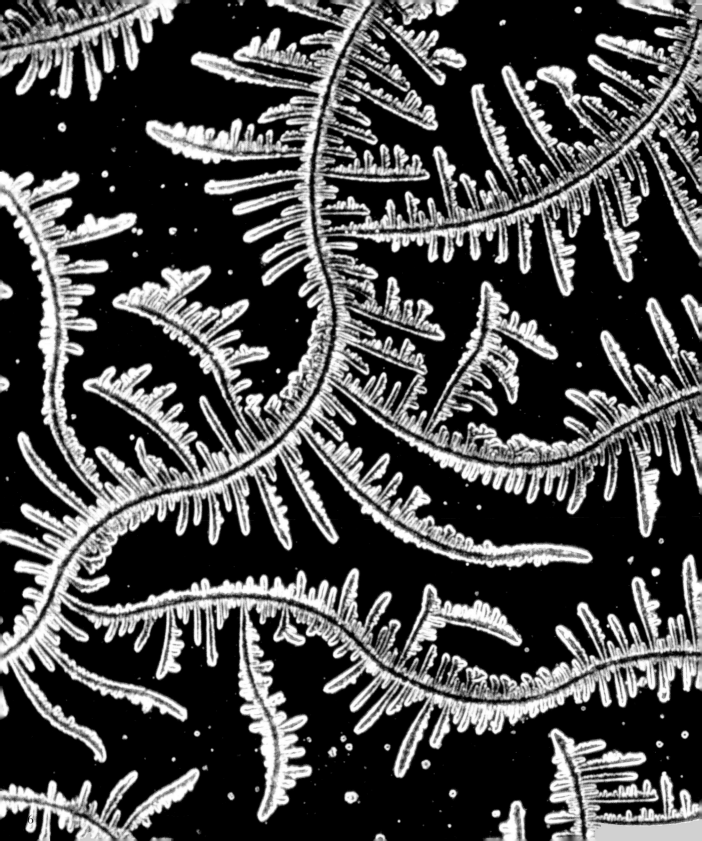

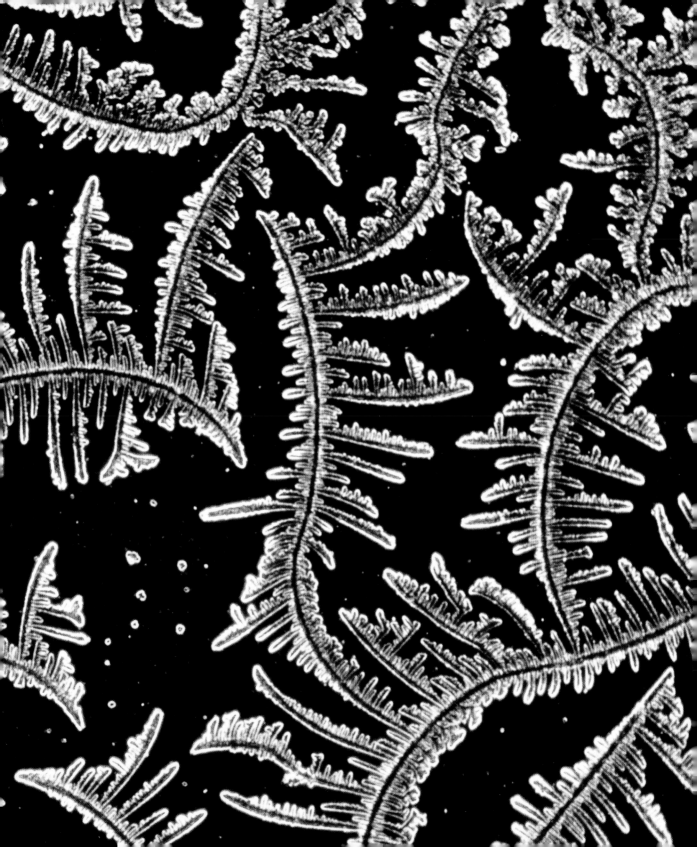

The egg surrounded by nutrient cells just prior to ovulation.

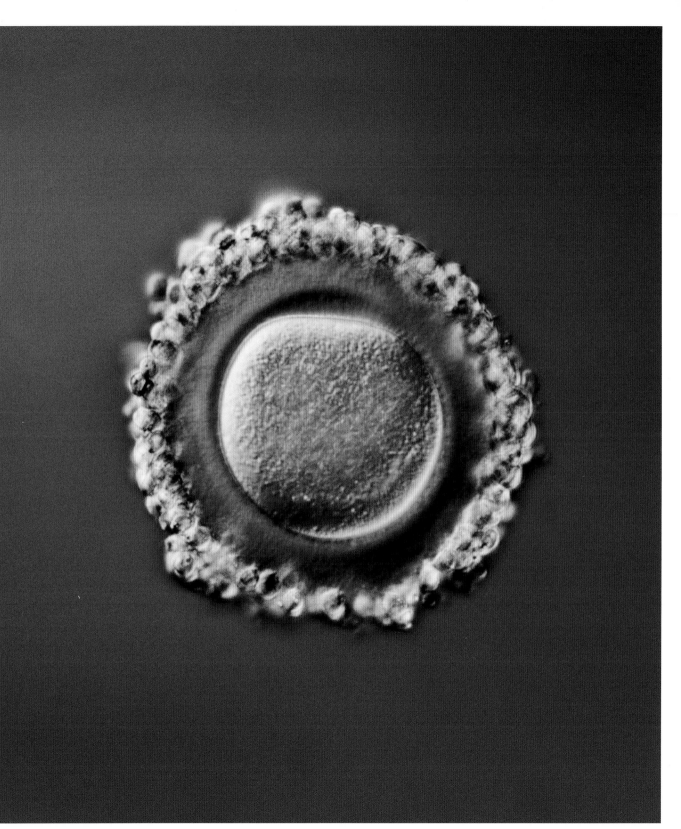

The egg, expelled from its follicle in the ovary, is caught up in the funnel of the Fallopian tube.

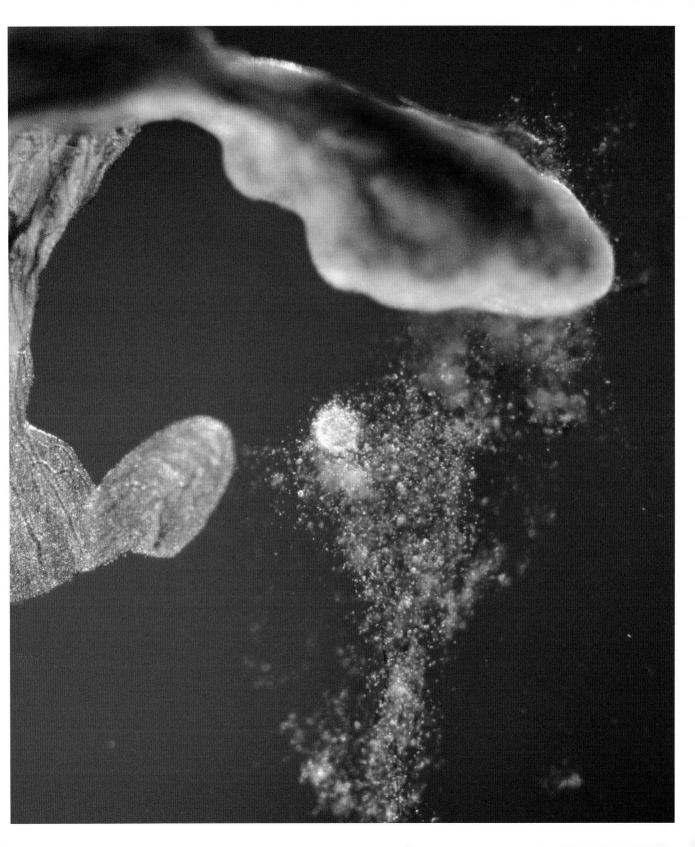

The sensitive folds of mucous membrane are ready to transport the egg into the Fallopian tube.

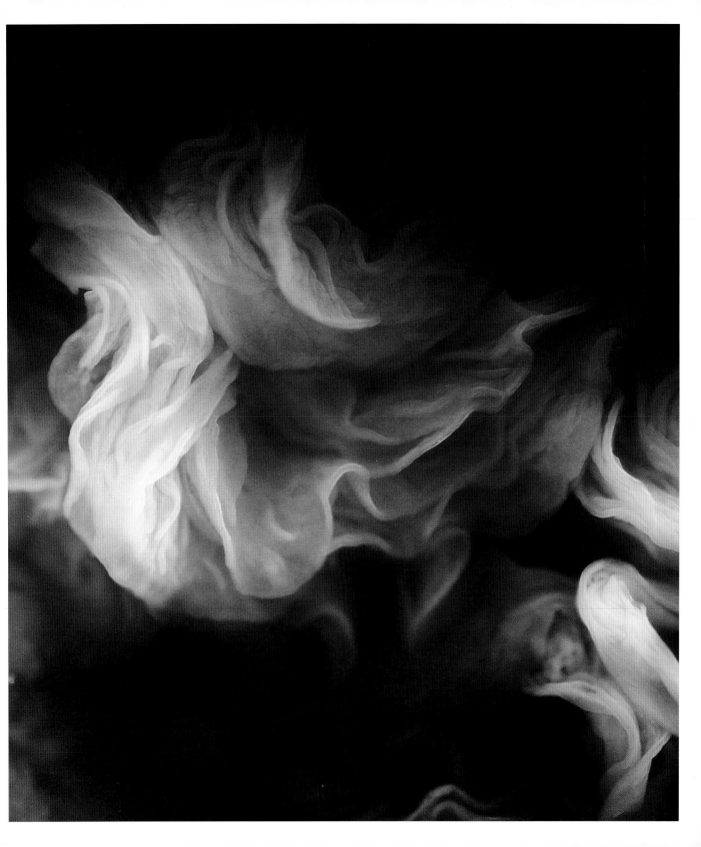

The liquid-filled follicle containing the egg has ruptured and is rapidly transformed to a corpus luteum.

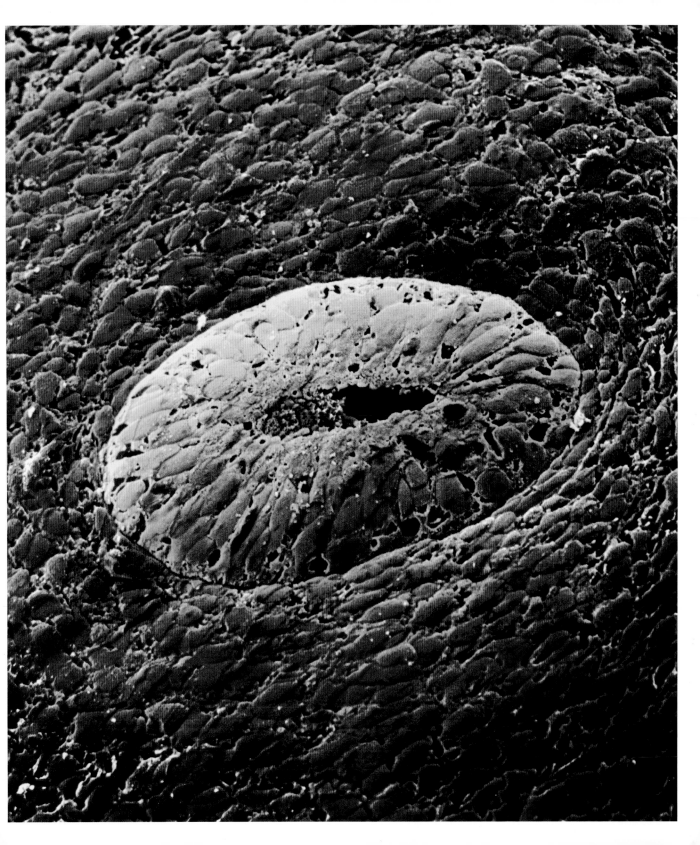

Half the chromosomes of the mature egg gather into a polar body at the edge of the cytoplasm.

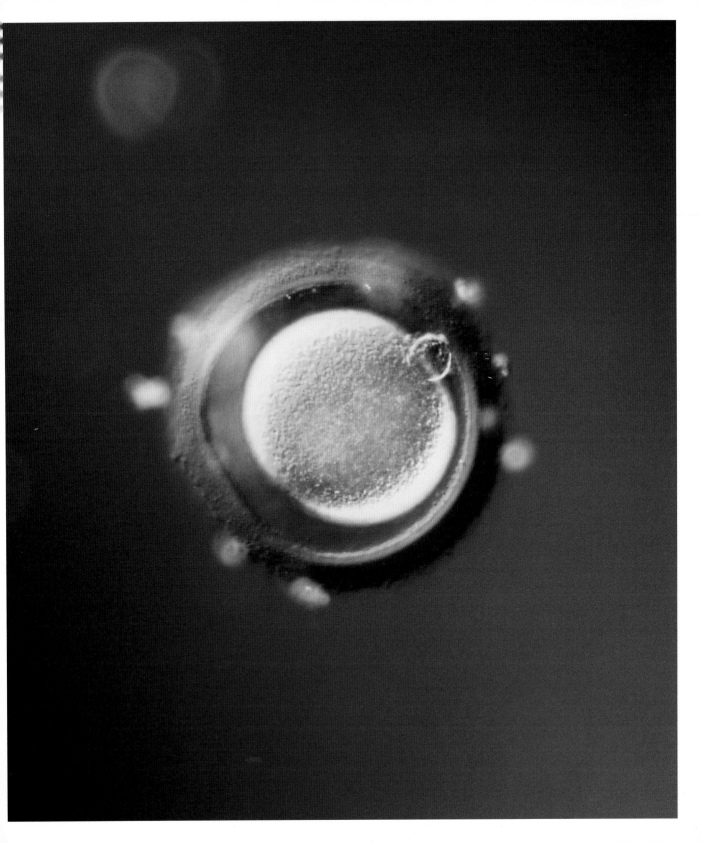

The surface of the egg is gradually exposed, but there are still plenty of protective nutrient cells.

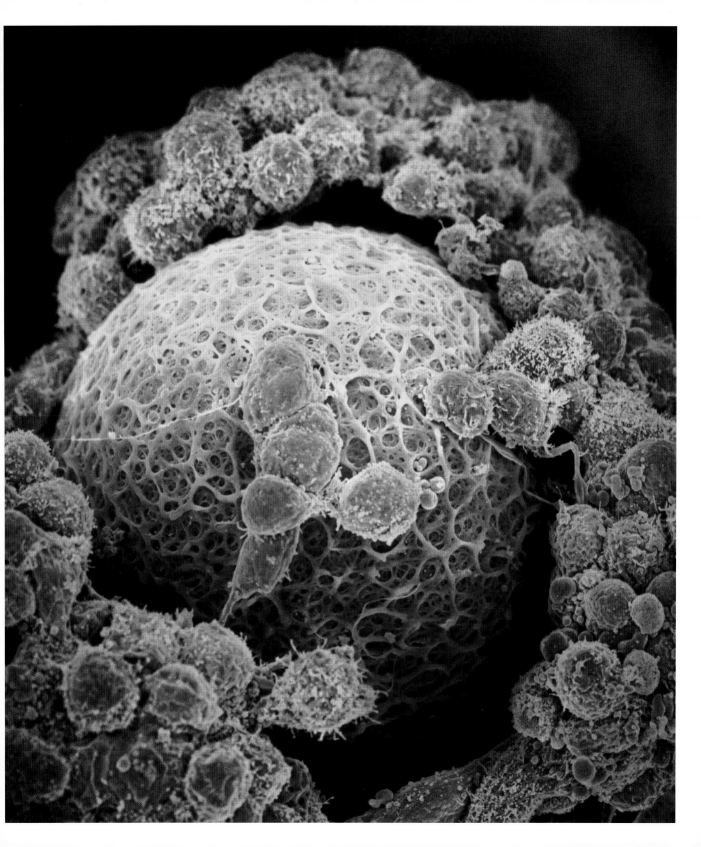

The egg awaiting the sperm in the outer part of the Fallopian tube.

PAGE 44 The egg rolls around the mucous membrane of the Fallopian tube. Now fertilisation can begin.

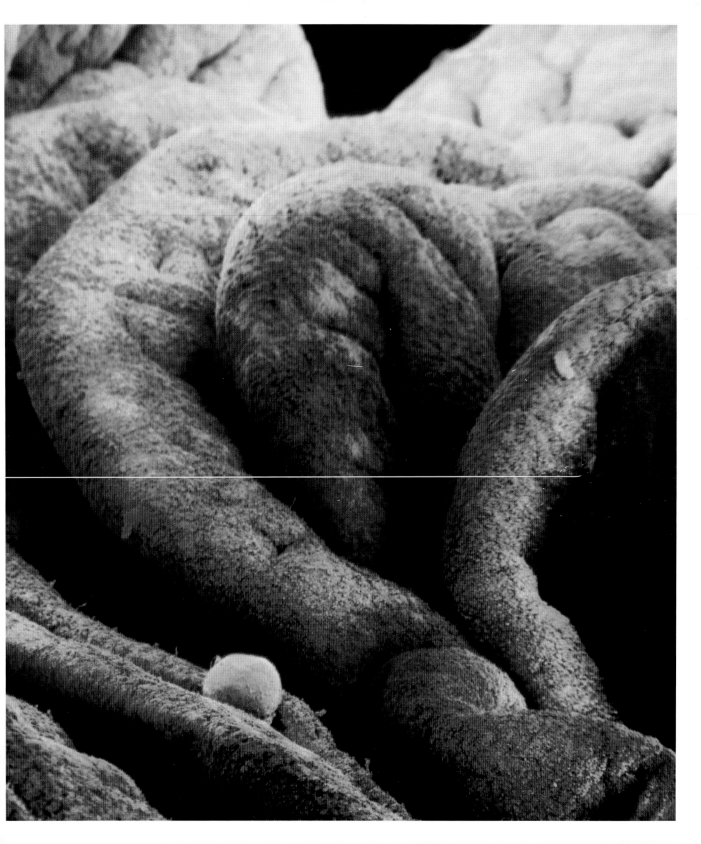

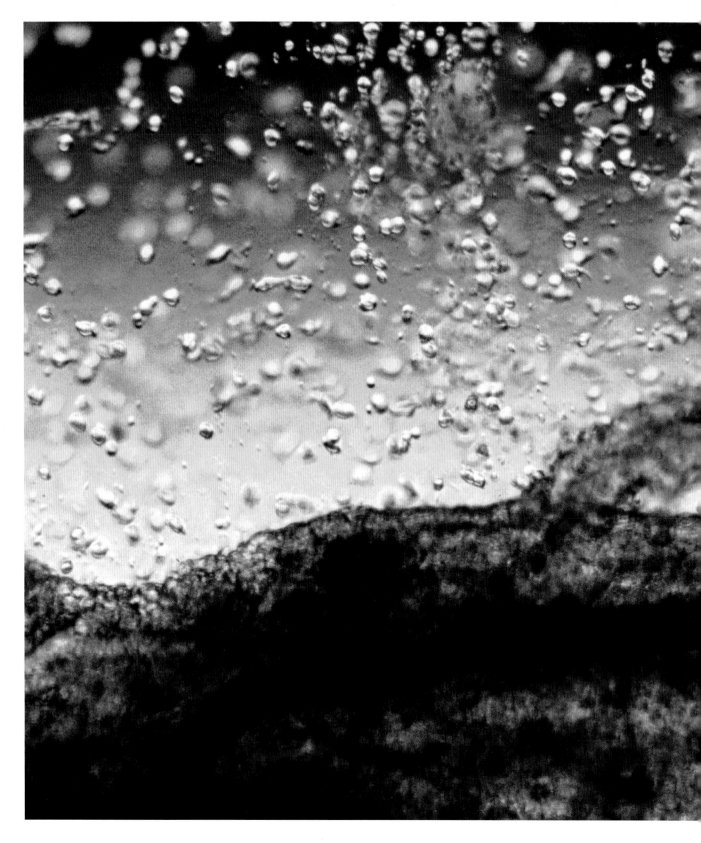

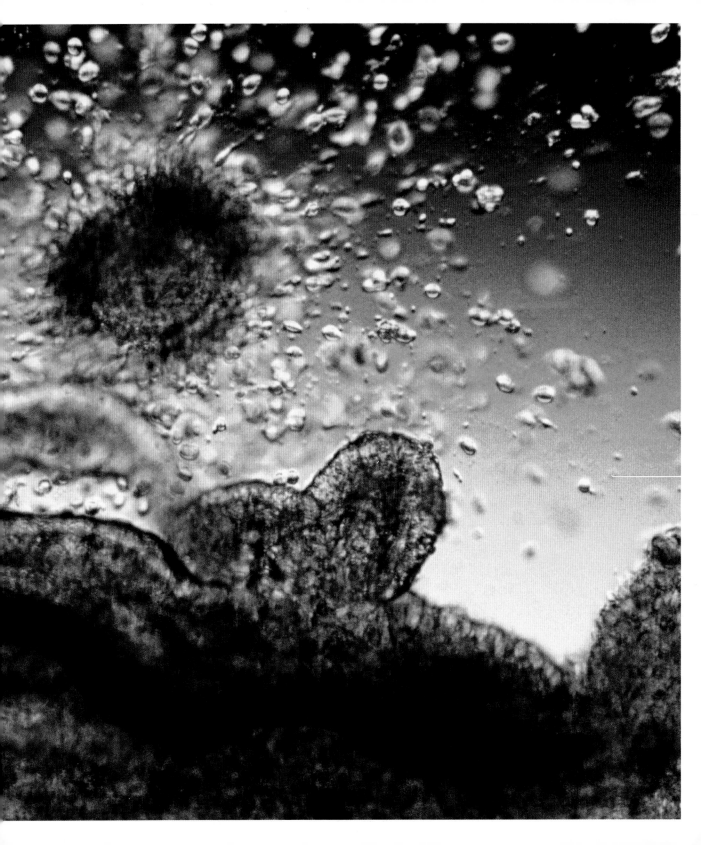

The Egg Cell

THE EGG (or oocyte), the female sex cell, is the largest cell in the human body. The mature egg, viable for fertilisation, is one tenth PAGE 30 of a millimetre in diameter, almost large enough to be visible to the naked eye. The nucleus, where the chromosomes constituting the woman's genetic material are stored, is much smaller. The cytoplasm surrounds the nucleus and contains further genetic material in the so called mitochondria–small fuel packs that supply the egg with energy.

All the eggs a woman will ever produce, four to five million, are in her ovaries from week 14 of the foetal stage in an immature form. By birth the number has decreased to approximately one million, and fifteen years later, about 200,000 remain. The eggs are stored in the ovaries and do not become viable for fertilisation until puberty, and usually then one at a time. In early puberty a young woman's ovaries begin to produce more œstrogen, the female sex hormone, her shape begins to change, and she begins to menstruate. Early periods are often somewhat irregular, but when they gradually become more punctual, this is a sign that the eggs are maturing and she has begun to ovulate.

A woman normally ovulates once a month, discharging an egg about two weeks after her last period. If the woman is in good physical and mental health, the pituitary, a little gland located below the brain, excretes hormones that are carried to the ovaries by the circulatory system. The ovaries react to this stimulus by increasing production of œstrogen and by making a few immature eggs begin to grow and mature. Usually a small cluster of eggs in one ovary react fastest to these hormonal signals. Four or five of the eggs, each encapsulated in an individual follicle, begin to prepare for ovulation. As a rule only one of these maturing eggs (oocytes) will be discharged from its follicle, which will have moved to the outer layer of the ovary. During the approximately thirty fertile years of a woman's life, ovulation takes place some four hundred times.

The ovulation process is completed in only a few minutes. The follicle is filled with liquid (10–15 ml/0.6–1 tablespoon) which, in addition to the oocyte, contains millions of cells that have been secreting œstrogen. A few hours prior to the actual ovulation process, the oocyte rids itself of half its genetic information, sending it off to a little, round polar body on its surface. The remaining twenty-three chromosomes stay in the nucleus of the egg. The entire egg is surrounded by several layers of nutrient cells that will be transported along with it when the egg is caught up in the outer funnel of the Fallopian tube that spreads across the surface of the ovary close to the spot where ovulation occurs.

PAGE 38

PAGE 40

PAGE 42

Once it has landed in the first, wide part of the funnel, the ampulla, the egg awaits the arrival of possible sperm. The enveloping nutrient cells begin to deteriorate. If no fertilisation occurs, the woman will menstruate within two weeks. Menstruation usually lasts three to five days, and is the result of the outer layer of the mucous membrane in the woman's uterus, where the fertilised egg could have attached itself, being rejected and replaced by fresh new cells. Every period marks the beginning of a new menstrual cycle, lasting about four weeks.

Longitudinal section of a sperm. The genetic material is stored in the head.

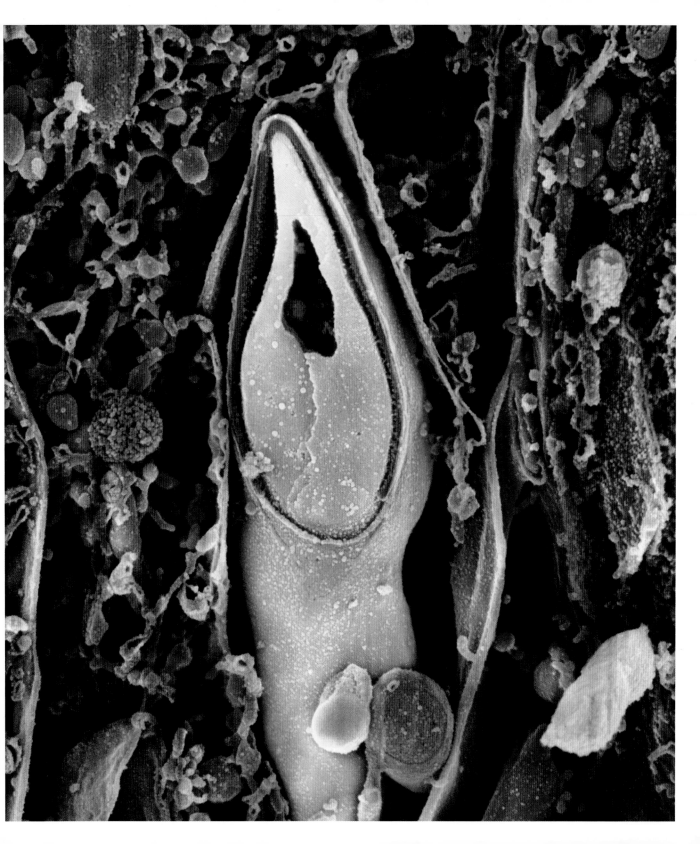

Millions of sperm are produced in the coiling seminal canals that fill the testicles.

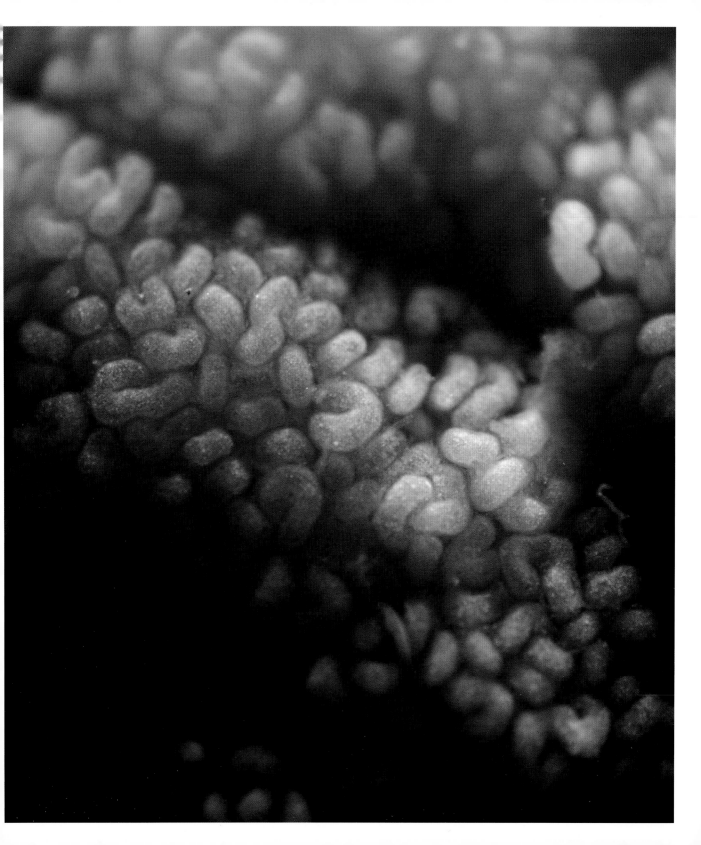

Cross section of a seminal canal with almost mature sperm at the centre, which are then transported to the epididymis.

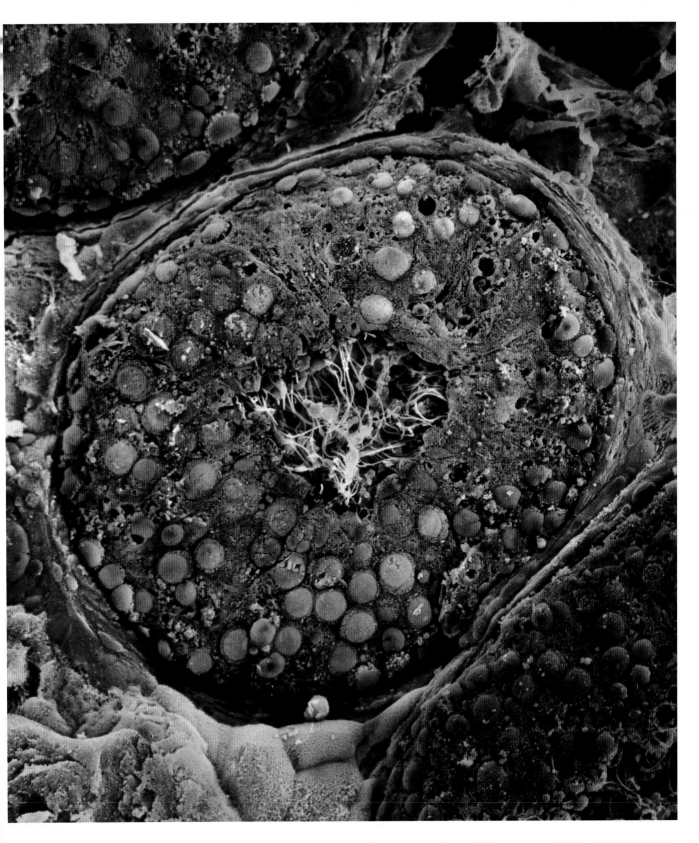

In the seminal canal, each maturing sperm divides into two spermatides, with twenty-three chromosomes each.

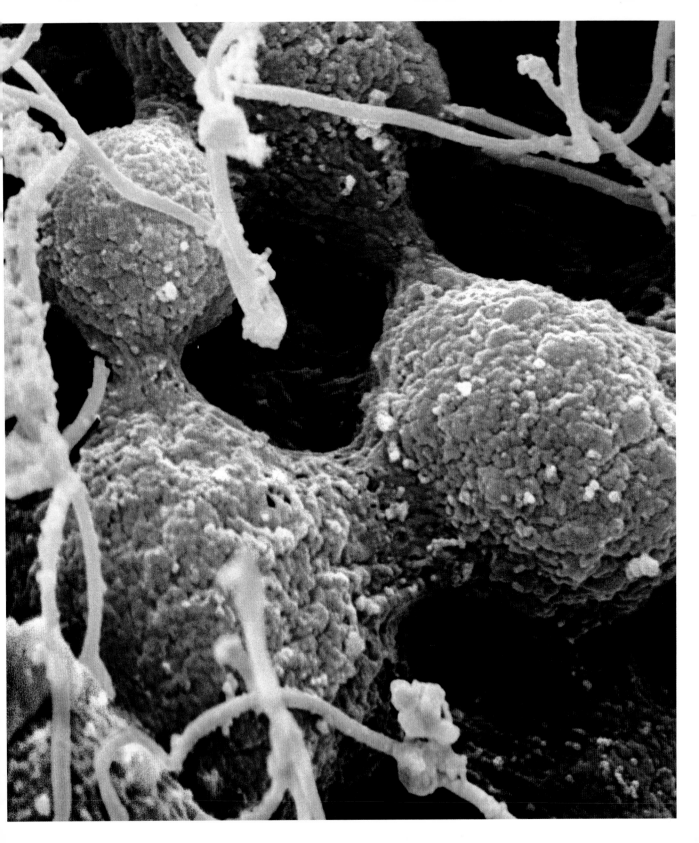

Crowds of immature sperm with rounded heads and primitive tails are gathered in one of the seminal canals.

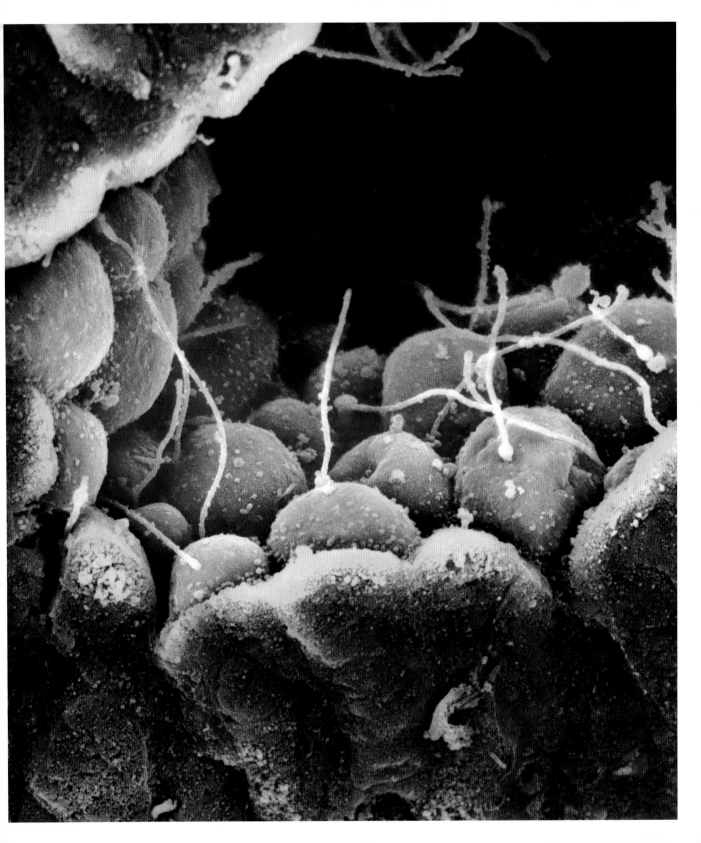

As the sperm achieve maturity they are transformed to a more streamlined shape.

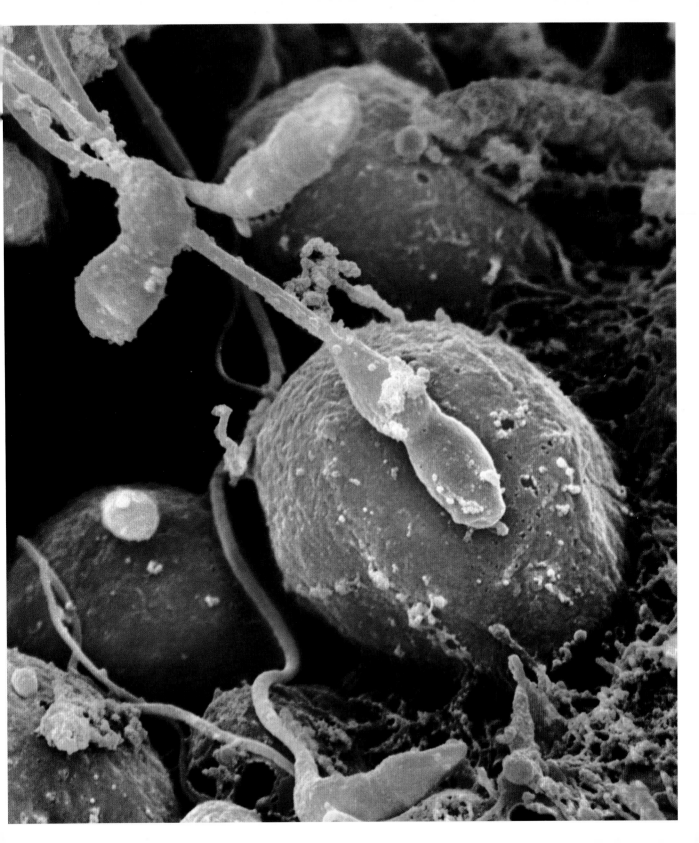

Mature sperm crowded into the epididymis. Their tails are now fully formed and have become mobile.

PAGE 66 Millions of sperm swim up through the cervix, trying to reach the egg in the Fallopian tube.

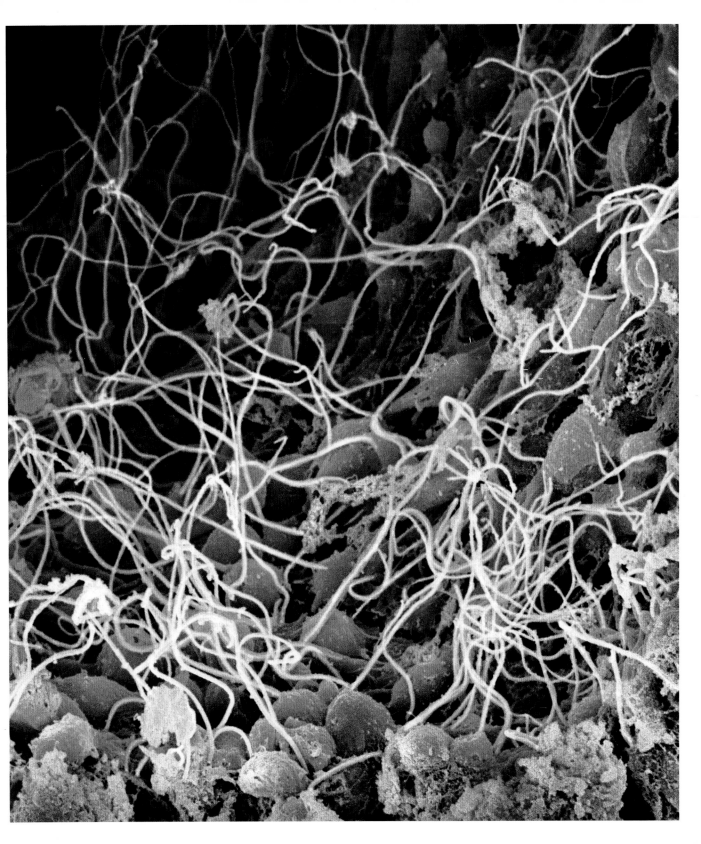

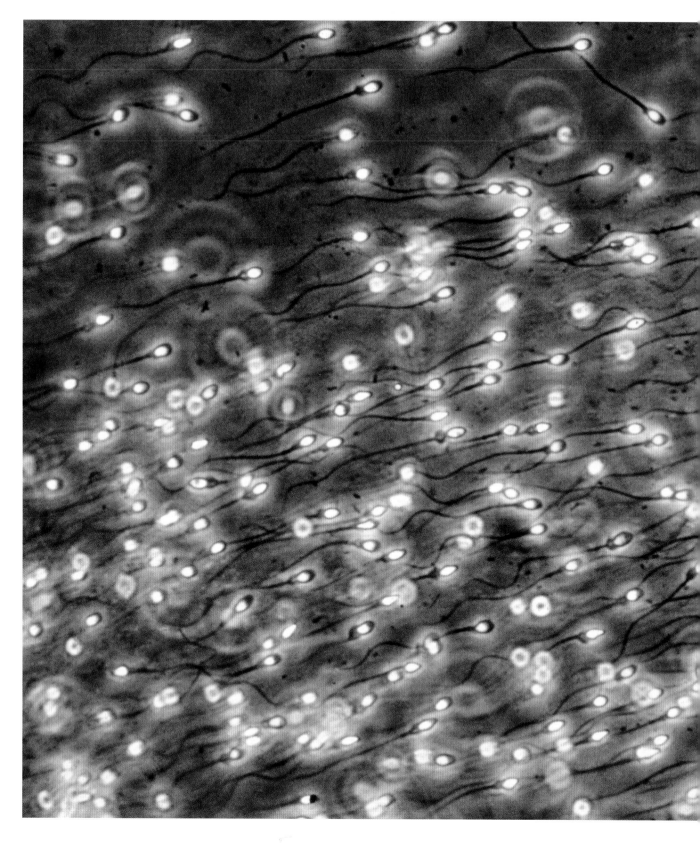

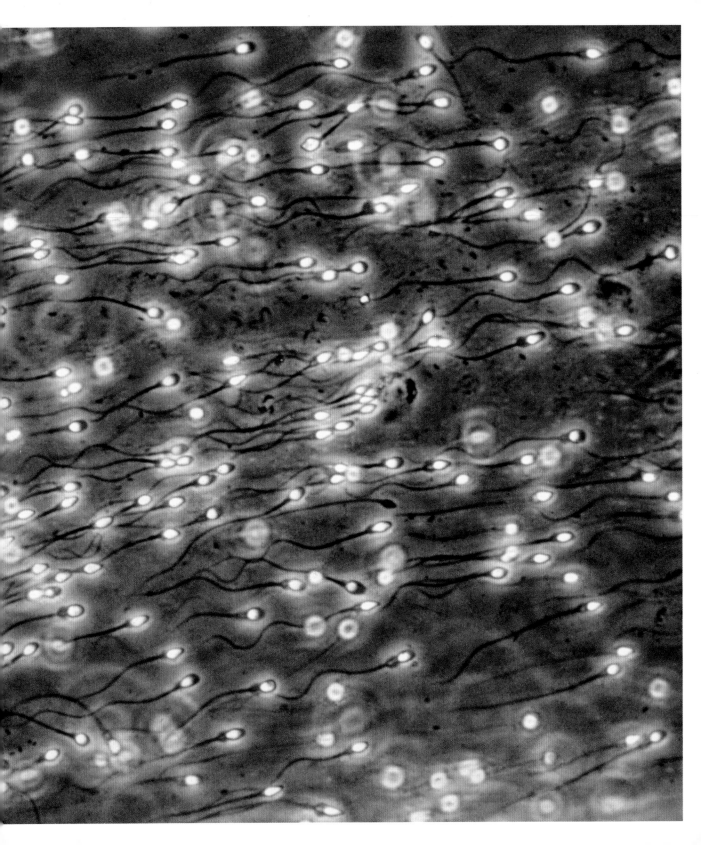

The Sperm

THE TESTICLES of a newborn boy contain millions of primitive sperm cells. As with women, the sexual development of boys and the production of viable sperm are primarily governed by hormones from the pituitary gland. This process is complete around the age of twelve to thirteen, at which time the testicles begin to produce testosterone, the male sex hormone, important for the development of the skeleton, muscle structure, and body hair. The testicles have another very key function as well. Beginning in puberty, they become the site of one of the most phenomenal production processes of the human body. Billions of sperm are produced there every month. Although the speed and quality of sperm production declines gradually over the years, some men continue to produce viable sperm when they are as old as eighty.

The body takes in total over seventy days to make a sperm. Sperm are produced in the meandering tangle of seminal canals that fill the testicles. These, in turn, are divided into coiling compartments. The canals are several hundred metres long, and the sperm begin to develop along the outer part of the walls, under hormonal control. As they mature, they are shifted toward the middle of the canal, where there is a cavity for further transport.

PAGE 54

During this first phase of development, each primitive sperm divides twice, producing four sperm. During one of these splits, the number of chromosomes in the sperm is divided in half, from forty-six to twenty-three. Each so called spermatide also develops a tail, after which it is transported, tail first, into the canal. The sperm are not yet mobile, but are pulled passively along in the secretion that flows through the passageways. The canals meet, merging into wider channels. Eventually the sperm reach the central "holding tank", the epididymis. There, and in contact with each other, the sperm complete final maturation. The midsection of each sperm takes its final shape, and its tail becomes mobile.

PAGE 58

PAGE 64

Sperm do not survive forever. If they are not ejaculated, they eventually die, making way for newly produced sperm with better potential to fertilise a woman's egg.

Every time an adult man ejaculates, his body releases 2–5 millilitres (0.3–1.0 teaspoons) of seminal fluid, containing up to five hundred million sperm. The sperm production process appears to be considerably less efficient than women's egg production. Many sperm lack either adequate propulsion ability or endurance of movement. There are also considerably more genetic aberrations in sperm than in eggs, which means that it is the egg, from a genetic viewpoint, that maintains the unique human code, while the sperm are constantly introducing variation. This makes the sperm an important agent in the process of human evolution.

Fertilisation

A sperm on its way to the egg in the mucous membrane folds of the Fallopian tube.

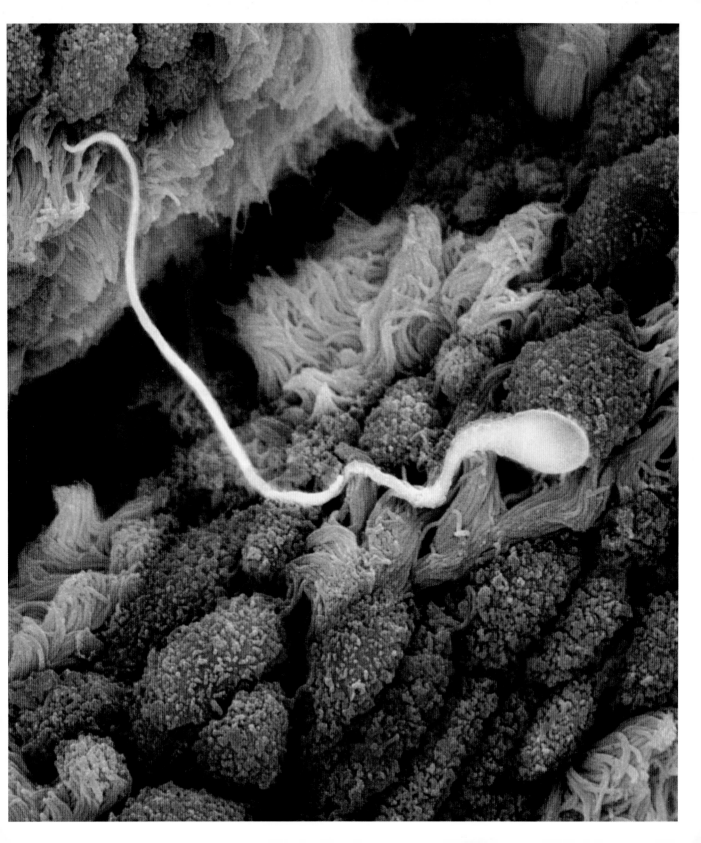

The first sperm are approaching the bare surface on the egg after their long swim.

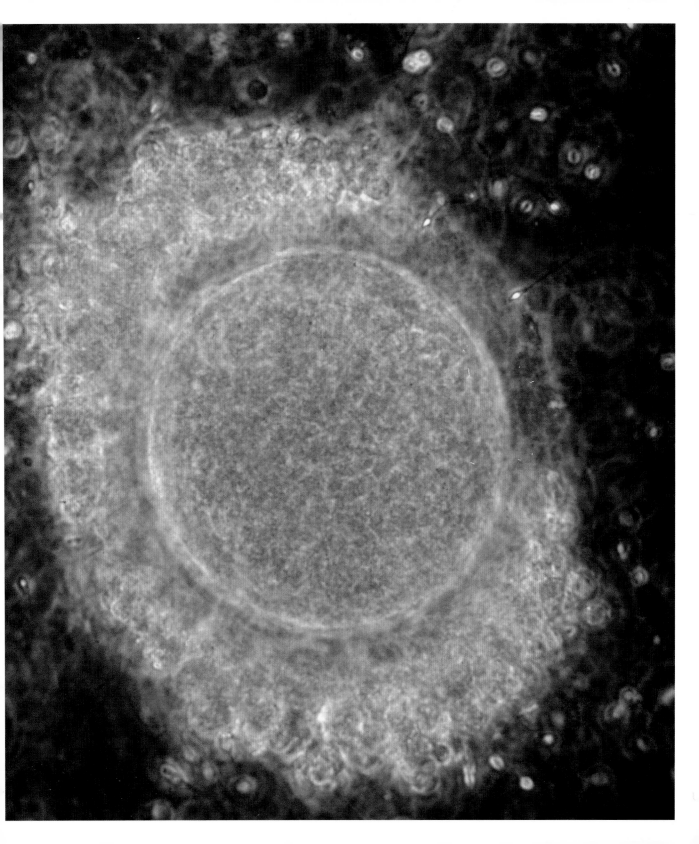

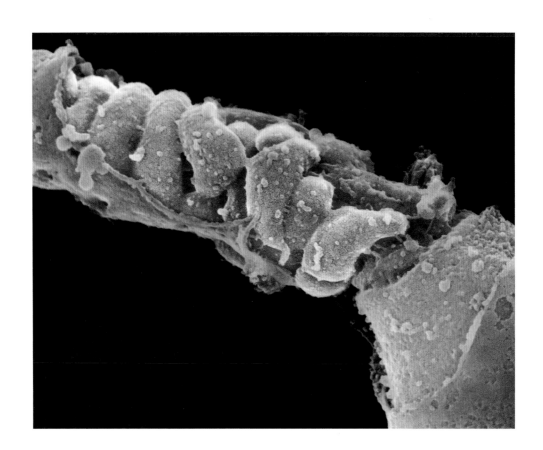

The midsection of the sperm contains tightly-packaged fuel packs, mitochondria, surrounded by sugary substances that fuel them.

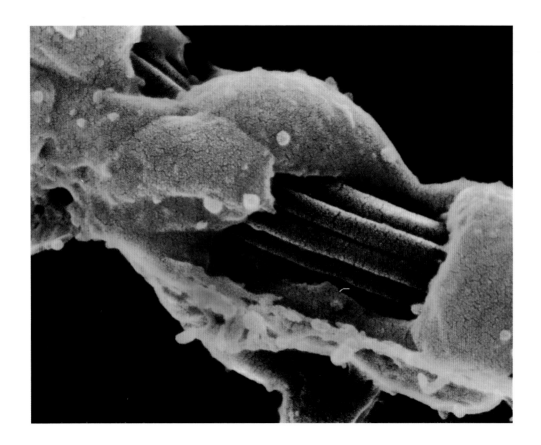

Behind the midsection is the sperm tail, a structure of lamella that governs sperm mobility. Approximately one thousand swishes of the tail propel the sperm one centimetre forward.

The sperm remove nutrient cells from the surface of the egg, to facilitate penetration of the cell.

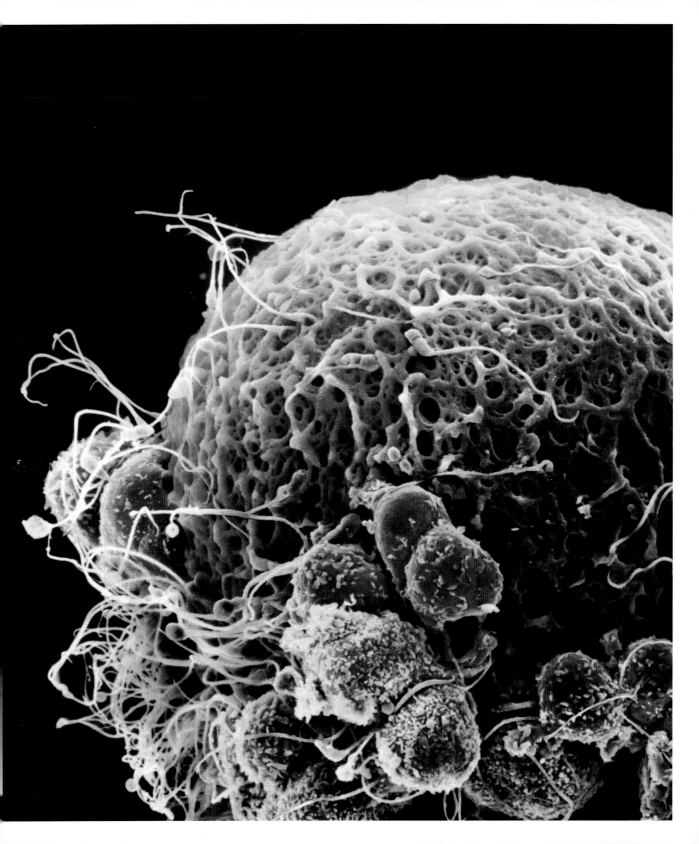

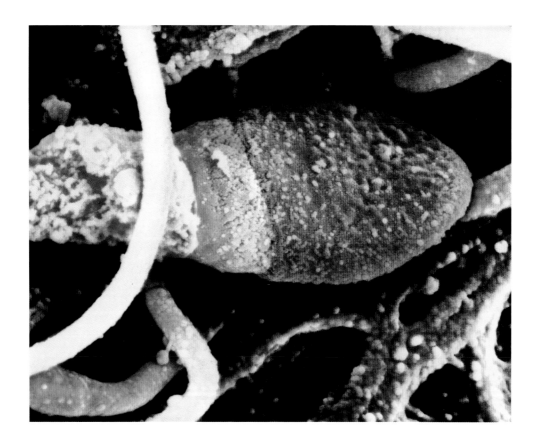

A covering, the acrosome, protects the head of the sperm from both mechanical and chemical damage on its journey to the egg.

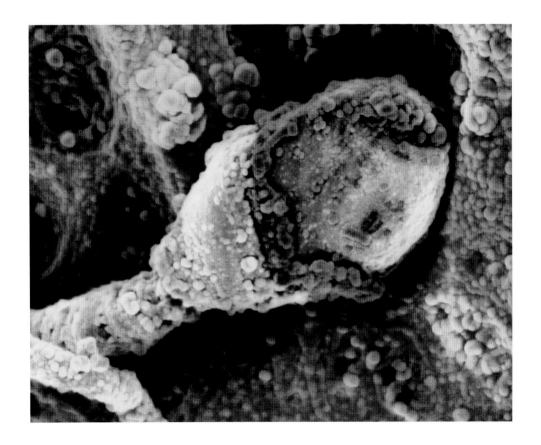

As the sperm strives to force its way into the shell, the acrosome falls away. Enzymes, albuminous substances, are released to help the sperm digest the nutrient cells surrounding the egg.

Two sperm have bored their way into the shell of the egg.

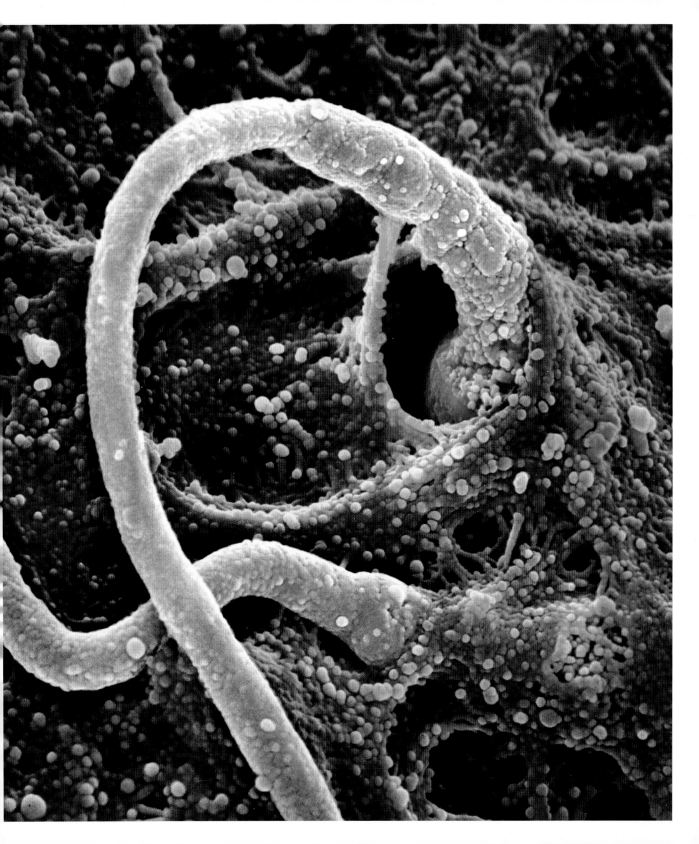

The entire head has penetrated the shell, and only the tail is still visible on the surface of the egg.

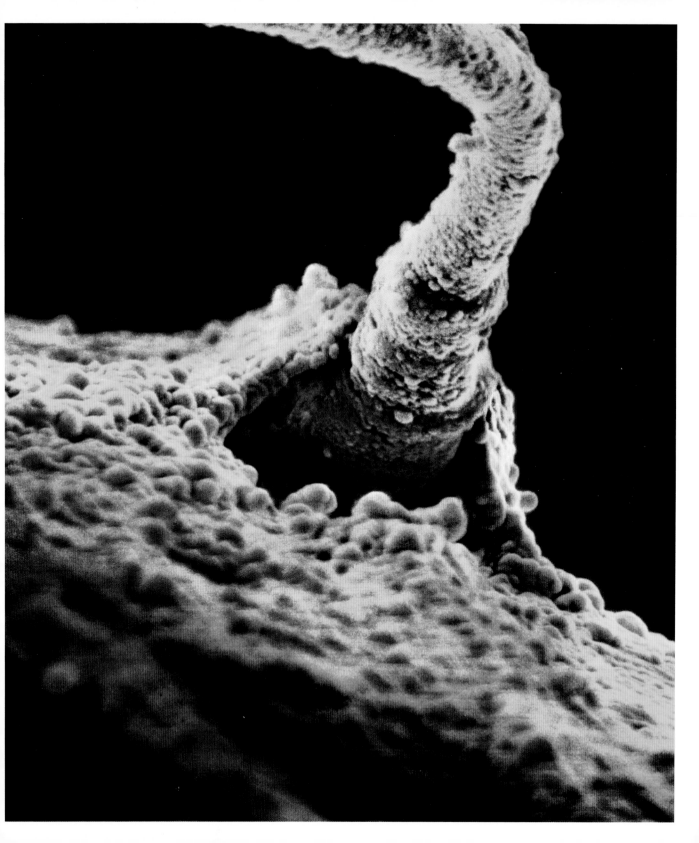

The successful sperm deep in the cytoplasm of the egg. The tail, no longer needed, has already dissolved.

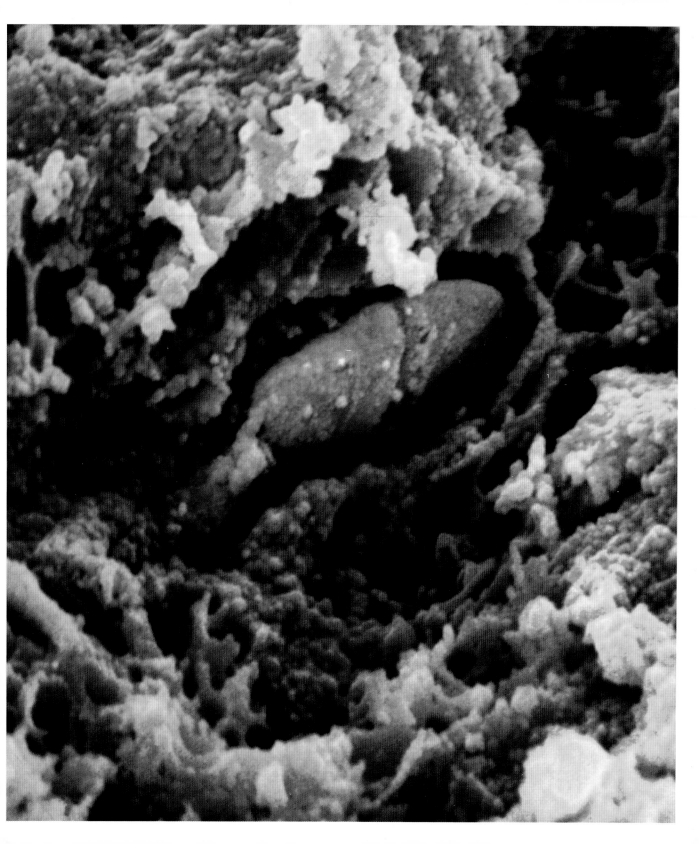

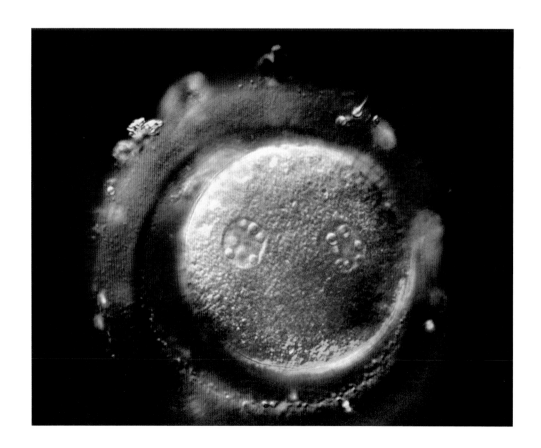

In the egg there are now two equally large cell nuclei. One is the swollen sperm head containing the man's genetic material, the other is the kernel of the egg where the woman's genetic material is stored.

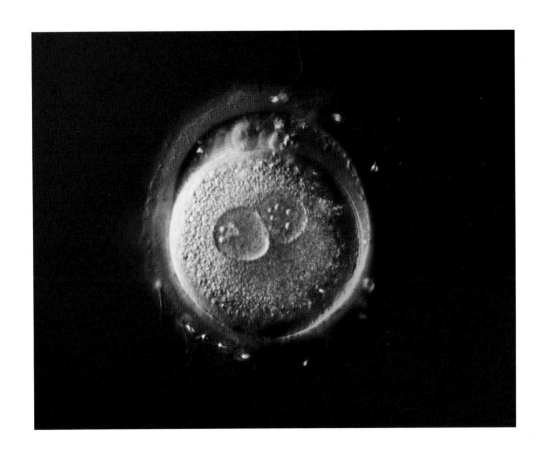

The two nuclei, with twenty-three chromosomes each, are drawn closer and closer.

Fusion of the nuclei. The genetic code of a new human being has just been created.

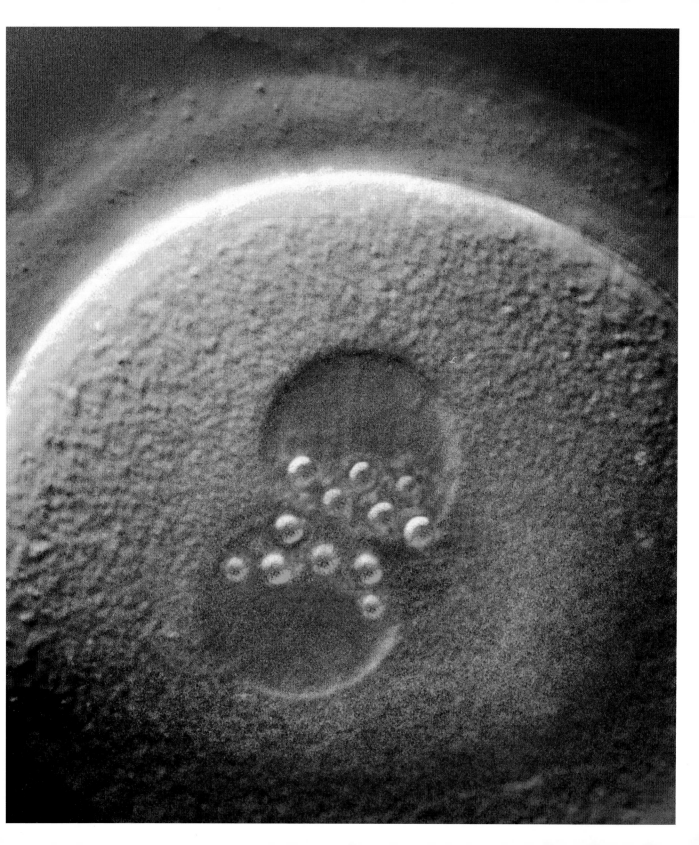

24 hours The first cell division after the fertilisation has taken place.

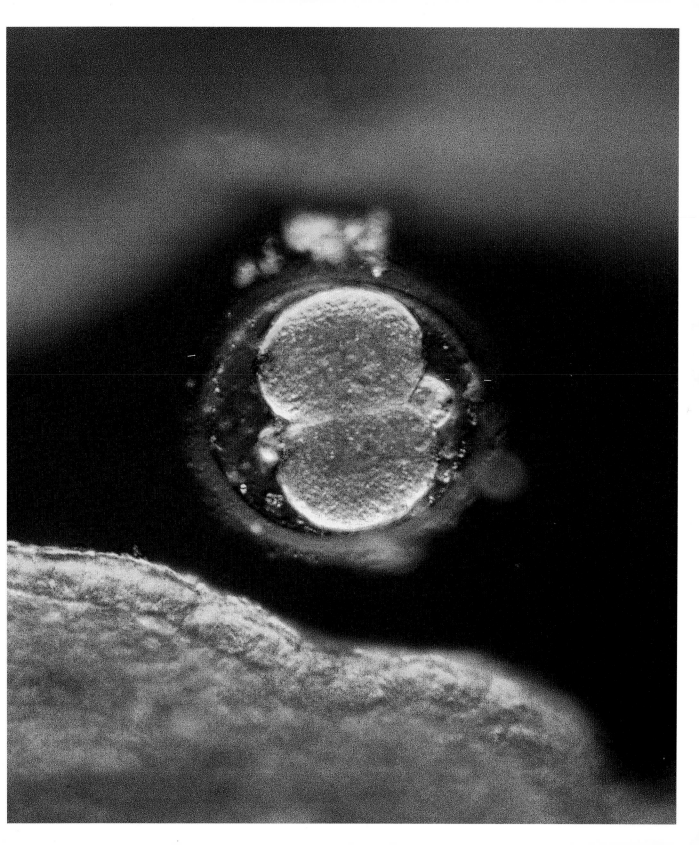

48 hours With the aid of the cilia in the mucous membrane, the fertilised egg slowly rolls deeper down the Fallopian tube.

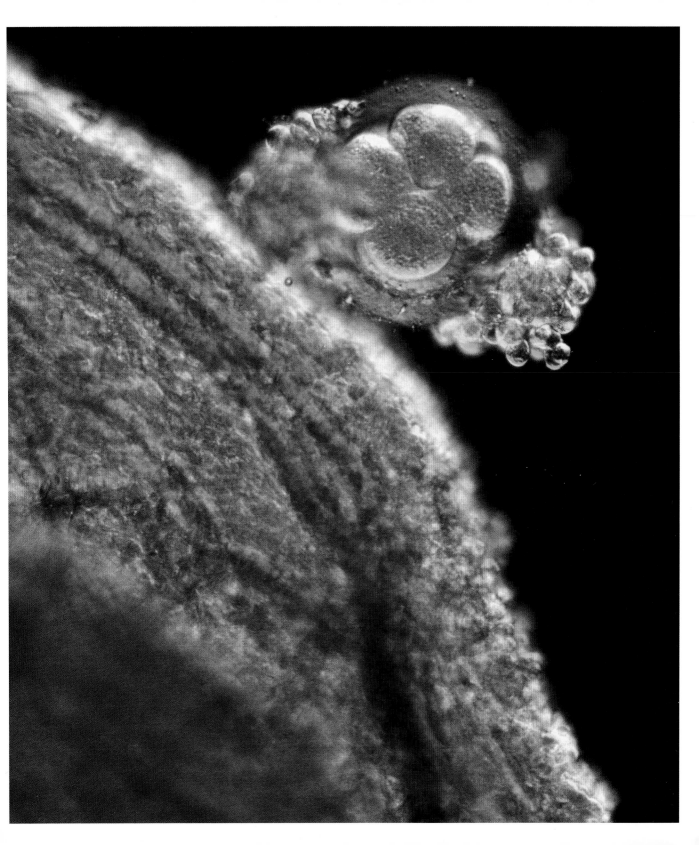

3–4 days Cell division continues. Early morula stage, 16–32 cells.

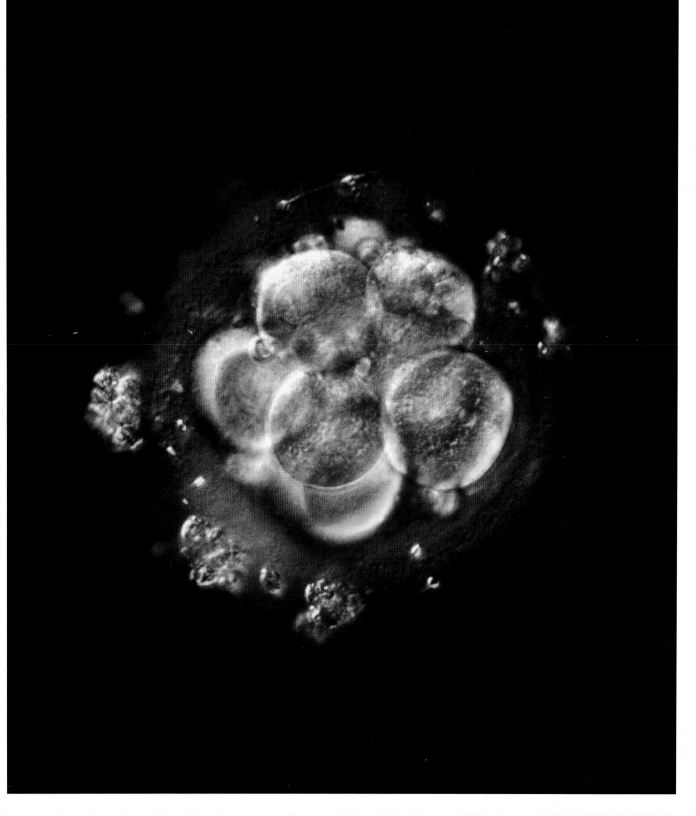

5 days When the cluster of cells becomes a blastocyst, it divides into the inner mass, the embryo, (left) and the placenta (right).

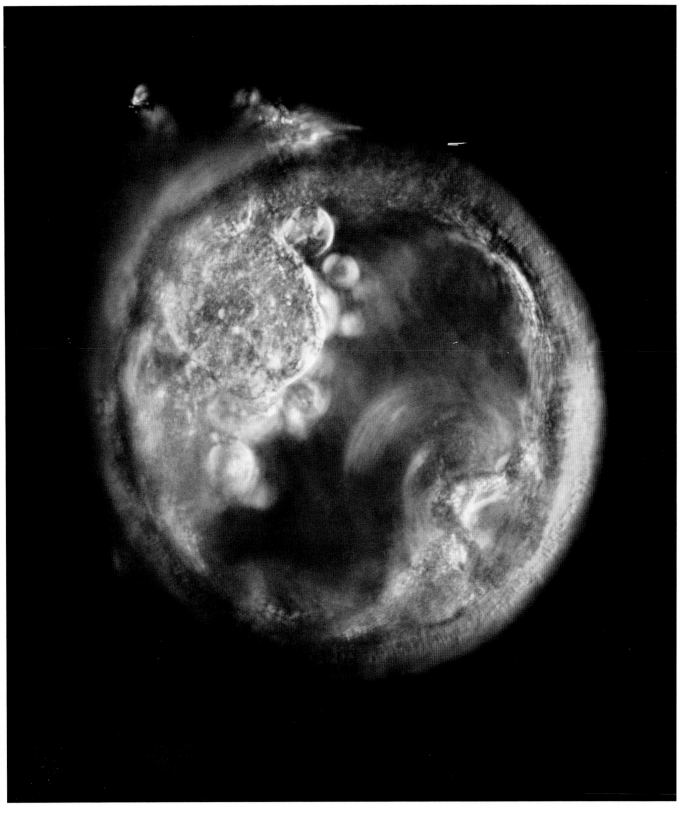

6 days The blastocyst has left the Fallopian tube and entered the uterus.

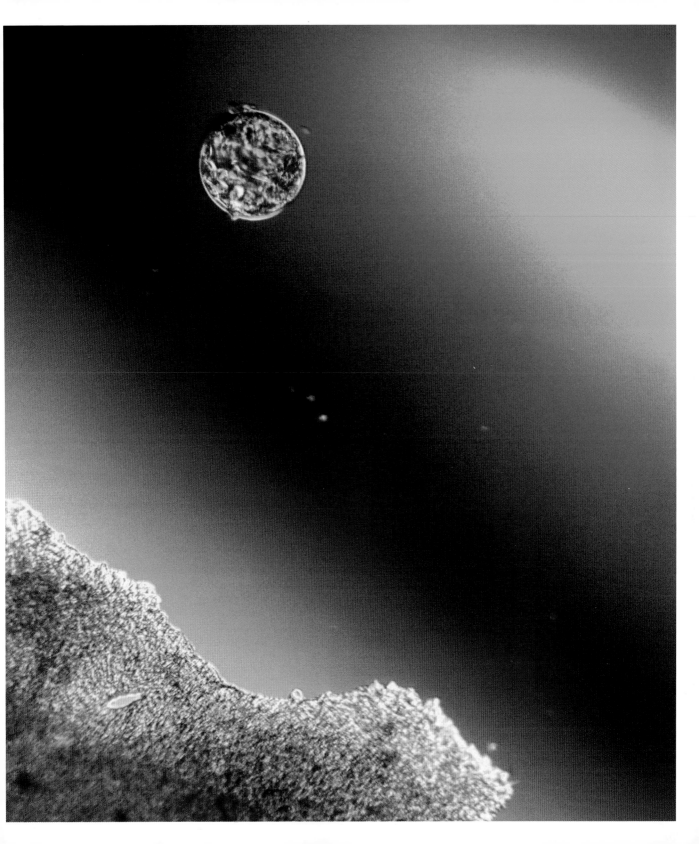

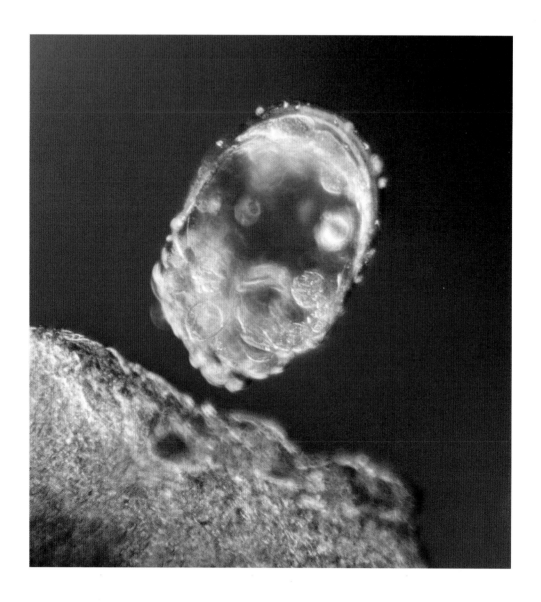

Before the blastocyst rests, it expands and contracts at least three or four times to shed the surrounding egg shell.

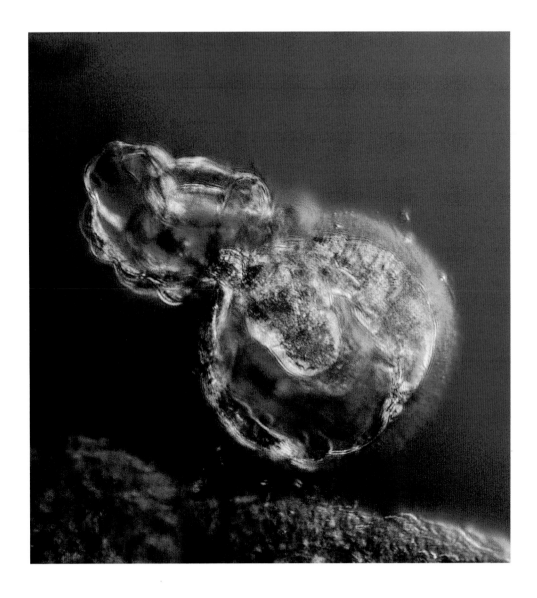

During the hatching process the blastocyst tumbles around inside the uterus, sometimes touching the soft mucous membrane lining.

7 days The uterine mucous membrane embraces the fragile cell mass. The eggshell is no longer needed.

PAGE 108 The embryo is expanding rapidly, and implanting into the uterine mucous membrane.

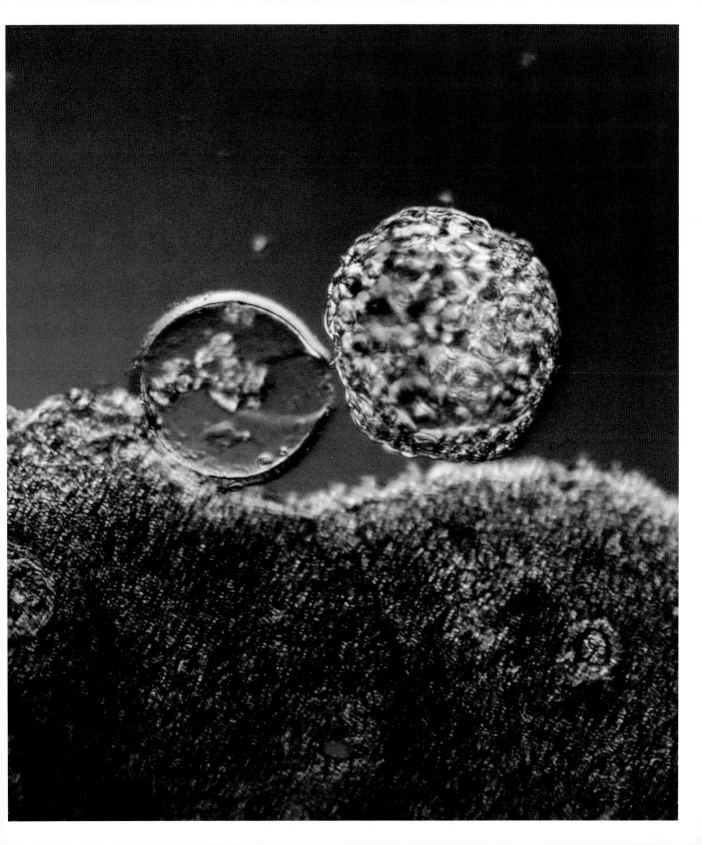

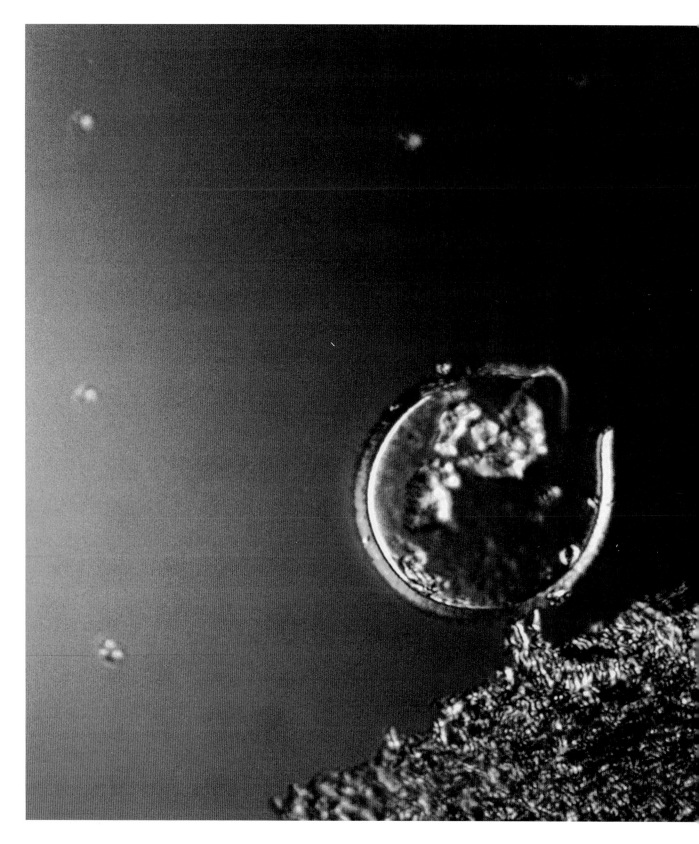

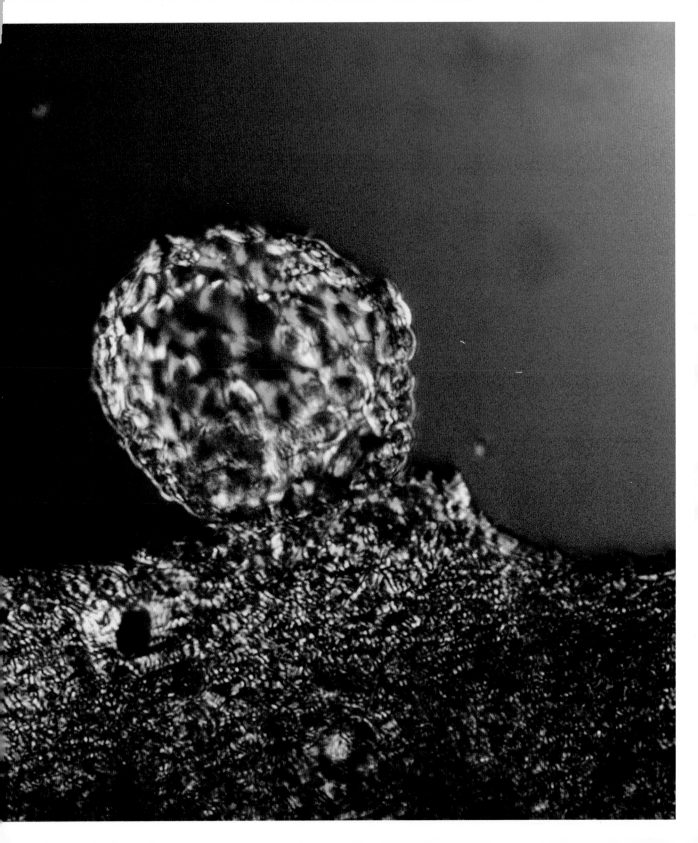

Human chromosomes sorted by pairs at the moment of division.

PAGE 112 The pairs of chromosome lined up. The largest chromosomes have the lowest numbers. Pair number twenty-three is unique. The combination consists of either two X chromosomes or one X and one Y. This photo shows the female chromosome arrangement.

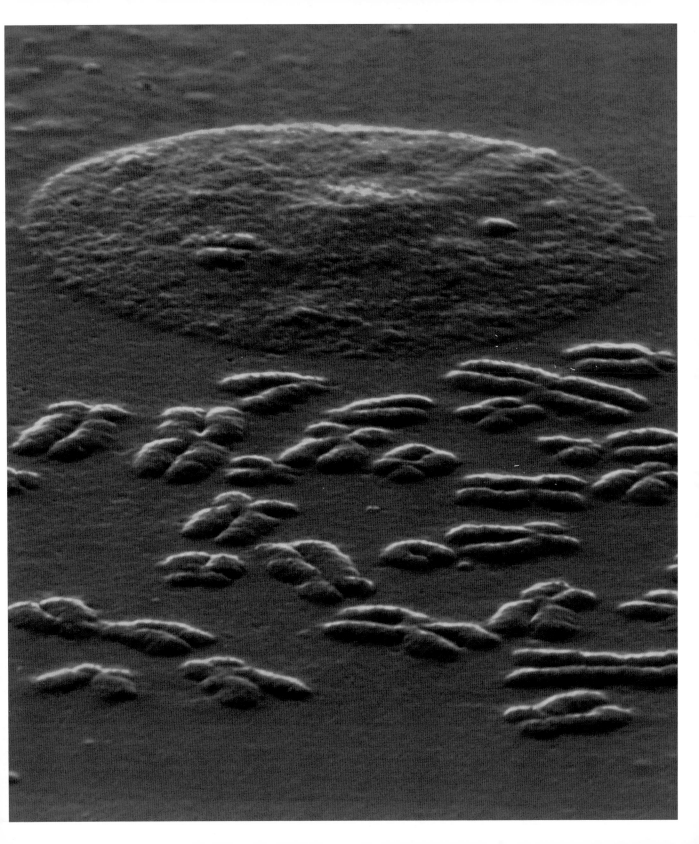

XX

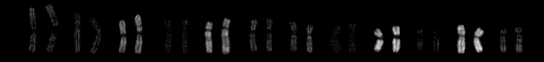

XY

Fertilisation

IF A NEW LIFE is to begin, a complex puzzle with many pieces must fit together perfectly. The egg, released from the surface of the ovary, is caught up in the ampulla, where it remains for a few days. This is the only window of opportunity for it to be fertilised by the sperm. When the sperm enter the woman's vagina they swim, PAGE 74 propelled by their swishing tails, via the cervix and through the uterus, reaching the Fallopian tube in less than half an hour. Their fuel packs are in the midsection, behind their heads, ambient sugar PAGE 78 molecules, stored in the mitochondria. If the woman has recently ovulated there will be an egg in the Fallopian tube, waiting to be fertilised. Because sperm can live for several days in the environment of the Fallopian ampulla tube, another possibility is that sperm may be awaiting the arrival of the egg.

At this point the egg is almost completely surrounded by an aura PAGE 80 of nutrient cells, the so called corona radiata. A number of sperm immediately begin to force their way toward the surface of the egg, through this impeding layer of cells. When they arrive, they find their way blocked by a strong shell, which consists not of cells but of a tough, almost hard cohesive material. The sperm will have to penetrate this shell to enter the cytoplasm of the egg, where the woman's genetic information is stored in the nucleus. Compared with the egg cell, a sperm is very small, but the genetic material stored in its head is equal in size and importance to that in the egg.

Each sperm functions more or less like a drill: the movement of the PAGE 84 tail propels the head around and around like the bit of a drill. The little nooks and crannies that develop make it possible for many sperm to penetrate deeper and deeper through the shell. The first PAGE 86 sperm to reach the inner surface of the egg and make its way into the cytoplasm is the victor; others that reach this enticing goal are prevented from entering after just a minute or two, thanks to the activation of a rapid chemical process. The head of the victorious PAGE 88 sperm then swells up. The midsection and tail of the sperm, which have now served their purpose, fall away and dissolve.

At about the same time as the head of the sperm swells up into a PAGE 90 nucleus, another nucleus is forming inside the egg. The genetic information from the woman has been stored in the nucleus of the egg, and now these two nuclei must meet and merge. The nuclei approach each other with the aid of so called tubulin filaments, which arise between the nuclei and guide their way. The nuclei PAGE 92 are drawn inexorably to one another and soon fuse.

After this fusion, the outer walls of the nuclei dissolve and all the genetic material that will become the new human being vanishes into the cytoplasm of the egg. The fertilisation process has been completed. Inside the egg shell there is now only one single cell, the original cell for all the billions of cells that will develop into the body of the future human being. Within hours, it will divide PAGE 94 for the first time, into two identical cells.

The fertilised egg remains in the ampulla for two to three more days, continuing to divide at twelve to fifteen hour intervals. Forty-eight hours after fertilisation, there are four cells, and twenty- PAGE 96 four hours later, eight. On the fourth day the fertilised egg is often described as resembling a mulberry (the morula). After another day and night there is a clearly visible hollow, after which the mo- rula is referred to as a blastocyst. This is also when the first clear PAGE 100 division of tasks among the cells can be detected. Some cells, referred to as the inner cell mass, will become the embryo; the rest will become the placenta.

The inner walls of the Fallopian tube have millions of tiny hair- like cilia, all swaying in chorus in the direction of the uterus, to prevent the embryo from slipping into the abdominal cavity. The wall of the tube also consists of muscles that can contract or relax. The transition from the wider to the narrower part of the Fallo- pian tube is a result of a muscle in the walls of the tube that has been tightly contracted until now. Between the fifth and sixth day after ovulation it relaxes suddenly to allow the blastocyst to pass

through. The tension in this muscle and its consequent ability to open and close are primarily regulated by ovarian progesterone, the level of which increases considerably just after ovulation. The journey through the last, narrow portion of the Fallopian tube takes no more than a few hours.

After travelling for five days, the blastocyst finally arrives in the spacious uterine cavity. Before it lands gently in the mucous membrane of the uterus, the entire embryonic sac contracts and expands at least three or four times. This is thought to be the first step in the egg hatching process. First a hole develops, through which the inner cell mass and the cells that will become the placenta pour out, after which the empty, transparent shell sails off and dissolves. While the outside of the capsule was relatively smooth and hard, the new surface of the embryo is more rippled and stickier, as if the entire embryo had been dipped in sugar solution. Shoots of sugarlike molecules reach out for the surface of the uterine mucous membrane which, in turn, has similar sugarlike molecules into which the little shoots fit. It is believed that in this phase the embryo emits chemical signals to its surroundings, which respond by sending signals to the embryo to indicate the optimal landing site, where it will grow and develop.

PAGE 102

PAGE 105

The uterus is well prepared for its task. Since ovulation, the mucous membranes have had nearly a week to develop and ready themselves for the needs of the embryo. Immunologically, the embryo is actually an invader, with a protein composition entirely alien to the mother, but in most cases sophisticated systems in the woman's body ensure that the embryo is welcomed rather than rejected. Although it is the inner cell mass of the embryo that takes the initiative to implantation, the surrounding placenta cells possess special penetrative abilities. Almost instantly, tiny blood vessels begin to grow in through the mucous membrane, receive hormonal signals from the developing placenta and transmit them to all the systems in the woman's body.

PAGE 106

THE GENETIC INFORMATION in the embryo becomes increasingly significant for the healthy development of the complete person. Every cell in the human body has a nucleus, which is where our genetic material is stored. Our genes are packed in forty-six chromosomes, arranged with great precision. This structure, with its forty-six chromosomes and approximately forty thousand genes, is common to all human beings. But there are small variations within the structure that determine the characteristics of each human being, and these little differences are what make every individual slightly different from every other in terms of appearance, behaviour, and talents. Since the genetic material in every cell of each human being looks identical, the details of an individual's genetic composition may be determined by examining any single cell.

PAGE 112

Genetic material consists of DNA molecules in the shape of an extended double helix, intertwined spirals of nitrogen-based chemical building blocks, designated by the letters A, C, G, and T. The different combinations of these building blocks give a very large number of different messages. If the DNA chain were laid out flat, it would be 1.8 metres long. The chain contains encrypted information, a total of three billion code characters. This same information is enclosed in the nucleus of every cell in our bodies.

Our cells multiply by division, and each time a cell divides two new ones, with exactly the same genetic material, are created. In a single second, in every part of our bodies, throughout our entire lives, thousands of new cells, identical to the old ones in the genetic material they contain, are being created.

As the cells of a bodily organ age, they expire in accordance with a special pattern, known as aptosis, and are replaced by new ones. The number of different types of cells in our bodies has been estimated to be two hundred and forty, some of which live much longer than others.

Sex cells, egg and sperm, differ from the other cells in the human body in that, at the moment of fertilisation, they only contain twenty-three chromosomes each. When the nuclei of the sperm and the egg fuse, their genetic material combines, with the same numbers of chromosomes coming from the woman and the man, bringing the total back up to forty-six chromosomes, in twenty-three pairs. The first twenty-two pairs of chromosomes are the same in both sexes. The twenty-third pair is the unique one, consisting either of two X chromosomes in women, or one X and one Y chromosome in men.

Immature eggs contain forty-six chromosomes, and the twenty-third pair is always two X chromosomes. But a few hours before ovulation, the number of chromosomes is reduced by half, to twenty-three. Immature sperm, too, contain forty-six chromosomes, but the number is also halved during the sperm maturation process. In the sperm, however, something unique happens, because when it splits into two parts, one contains an X chromosome and the other a Y. So it is the sperm, and not the egg, that determines the sex of a new human being.

Pregnancy

8 days The newly-hatched embryo rests at an optimal site and has been received by the mucous membrane.

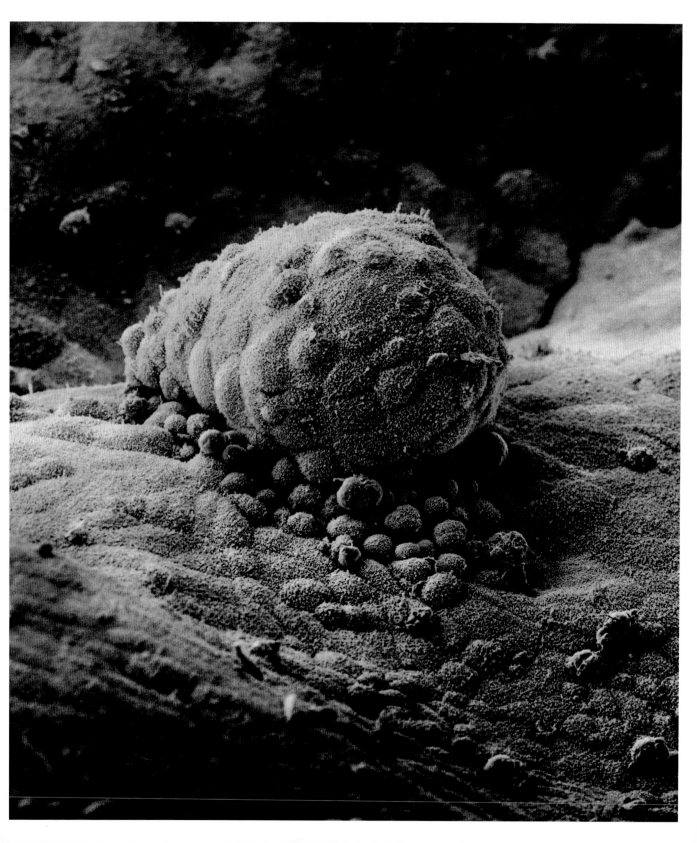

21 days The rounded cluster of cells have now become oblong in shape.

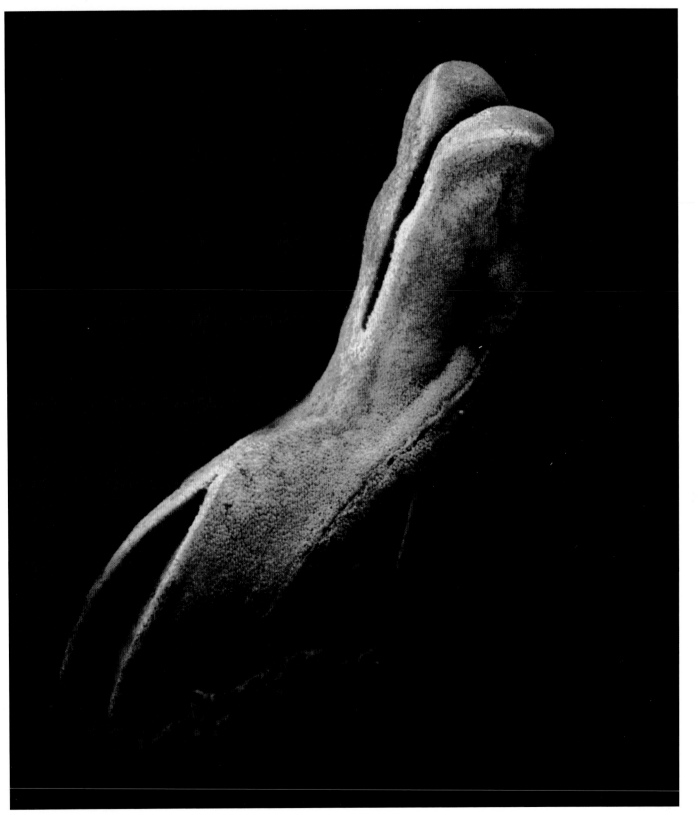

22 days As yet the embryo has no face, and we can see right into the brain.

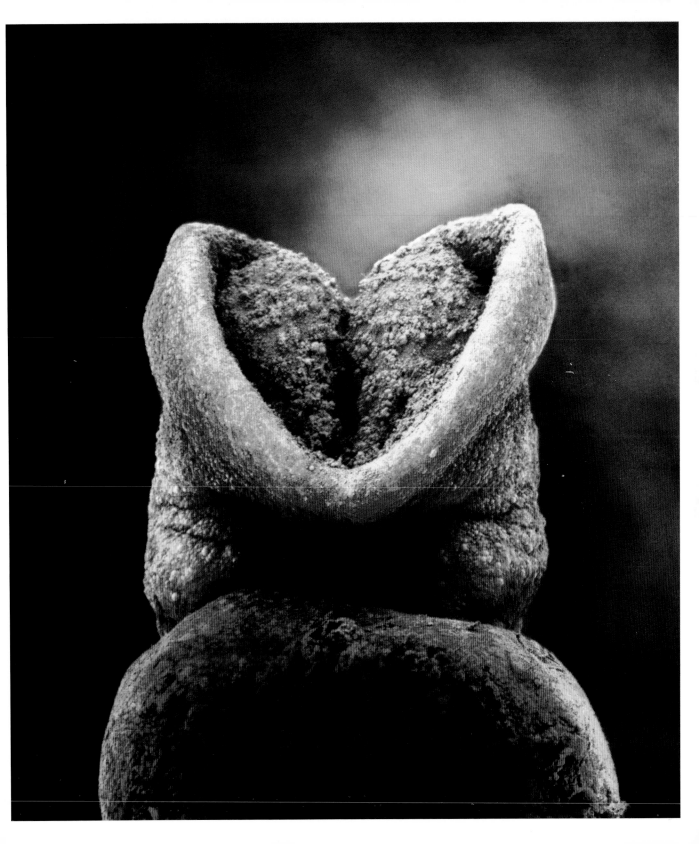

There are already nerve fibres protruding from the very first nerve cells in the brain.

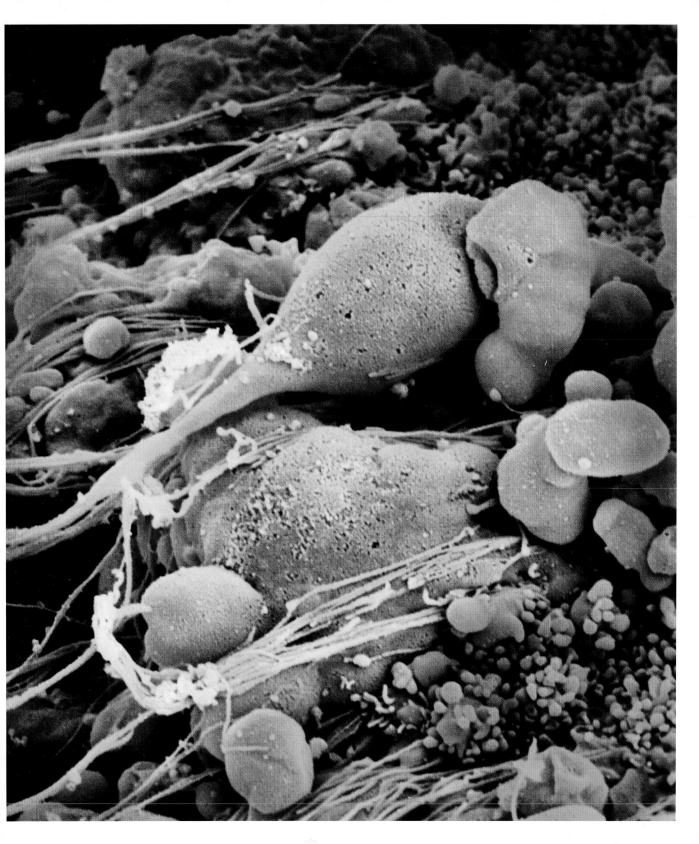

24 days The heart has just begun to beat.

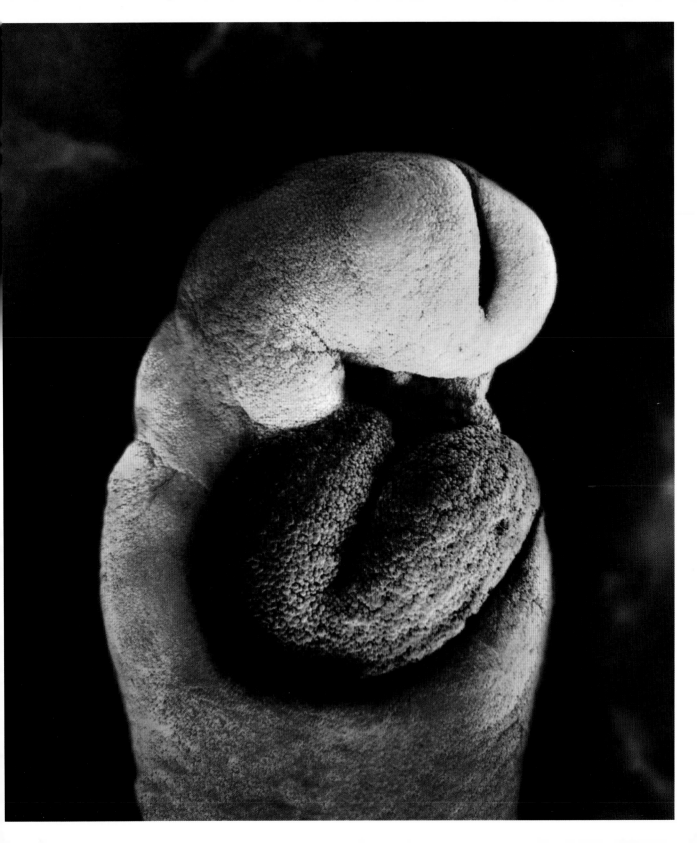

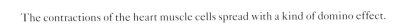

The contractions of the heart muscle cells spread with a kind of domino effect.

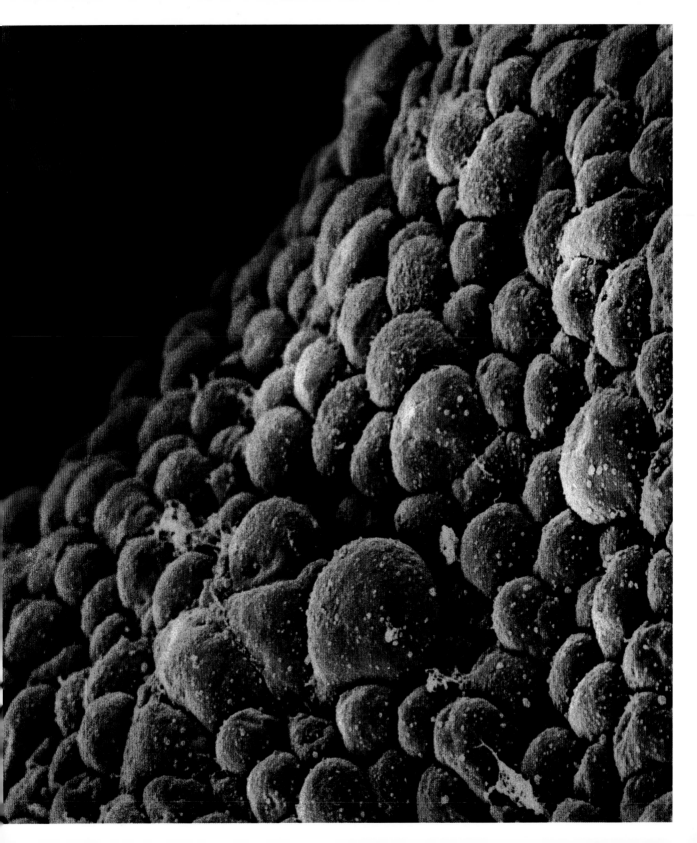

4 weeks The embryo from the back, with the primitive brain on the left. The head end of the body grows fastest.

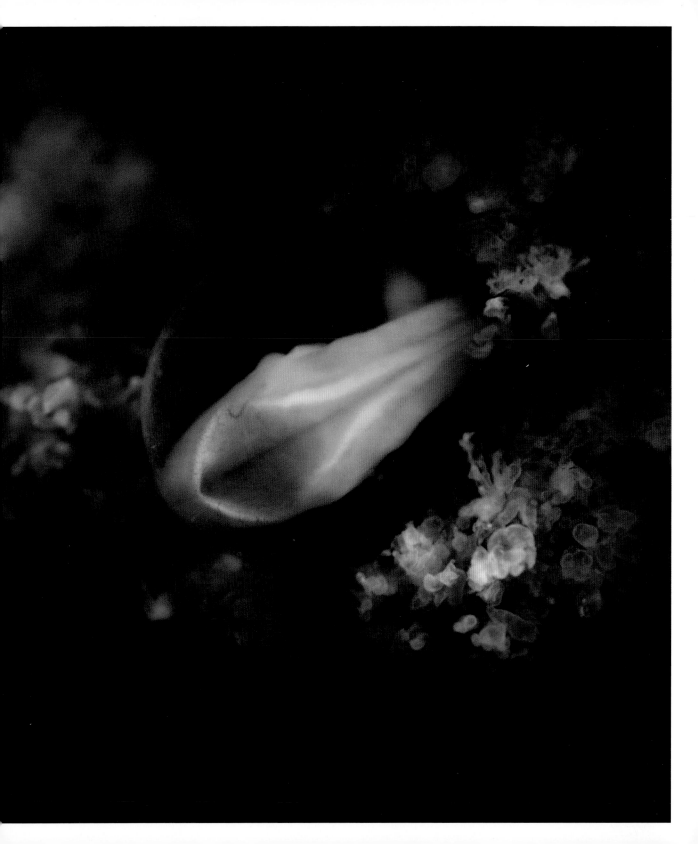

5 weeks Approximately 9 mm. The embryo in the foetal sac.

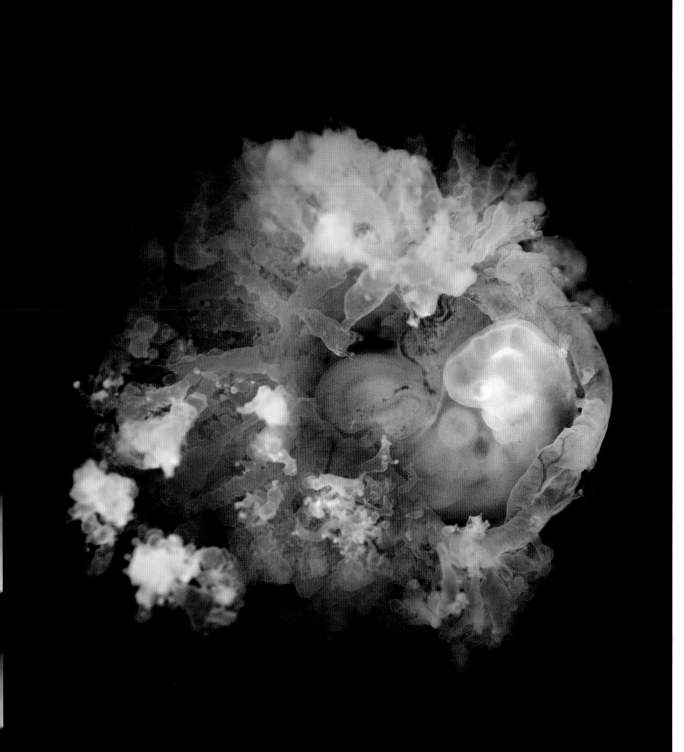

The placenta supplies the embryo with nutrients and oxygen via the umbilical cord. Future hands and feet are no more than just little buds.

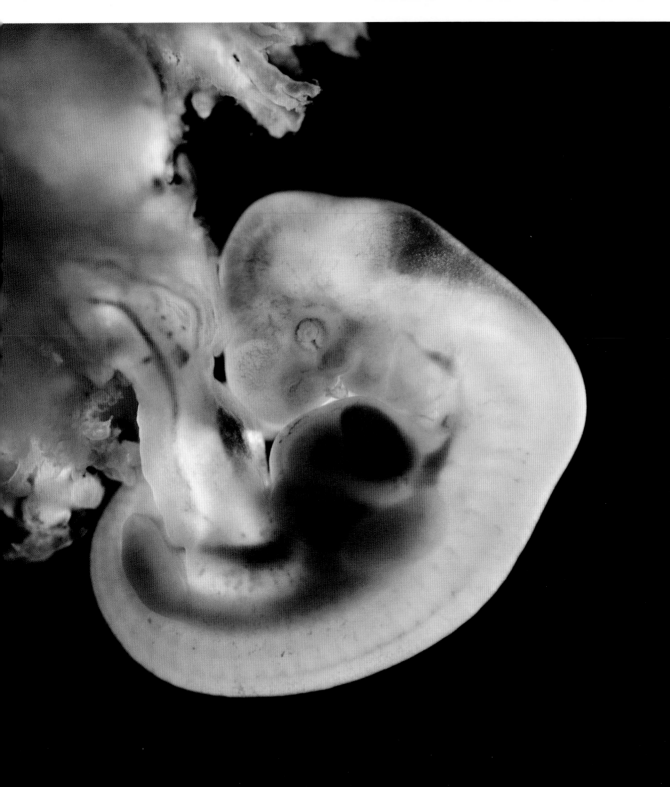

Skull bones close around the primitive brain.

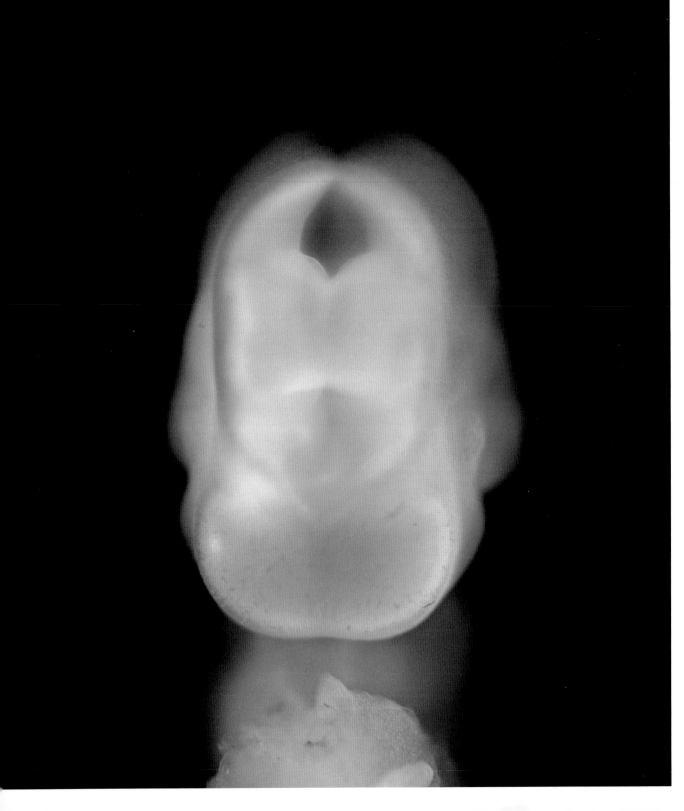

A face develops, with openings for the mouth, the nostrils, and the eyes.

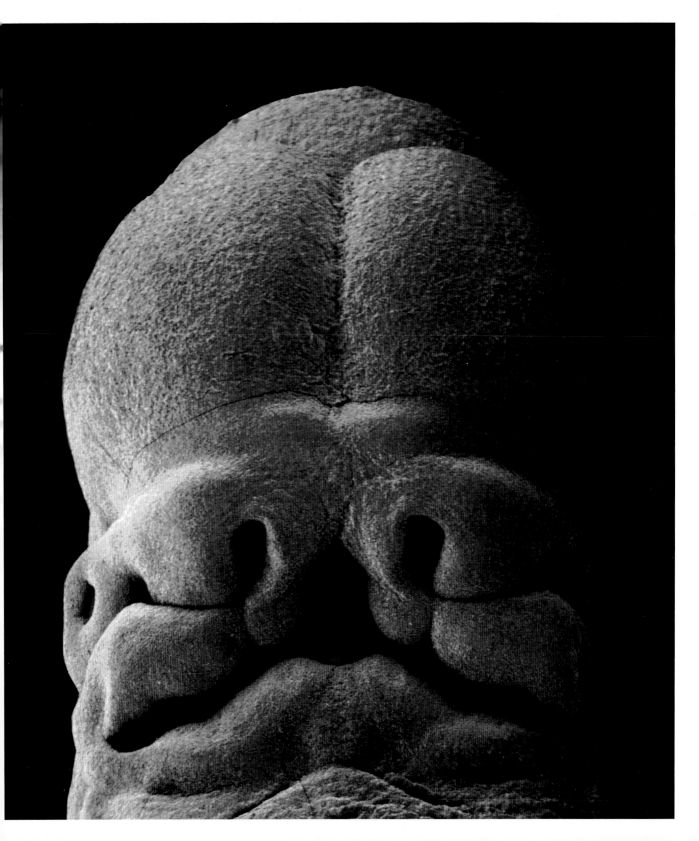

6 weeks The full spinal column is visible. The yolk sac is suspended like a balloon to the left.

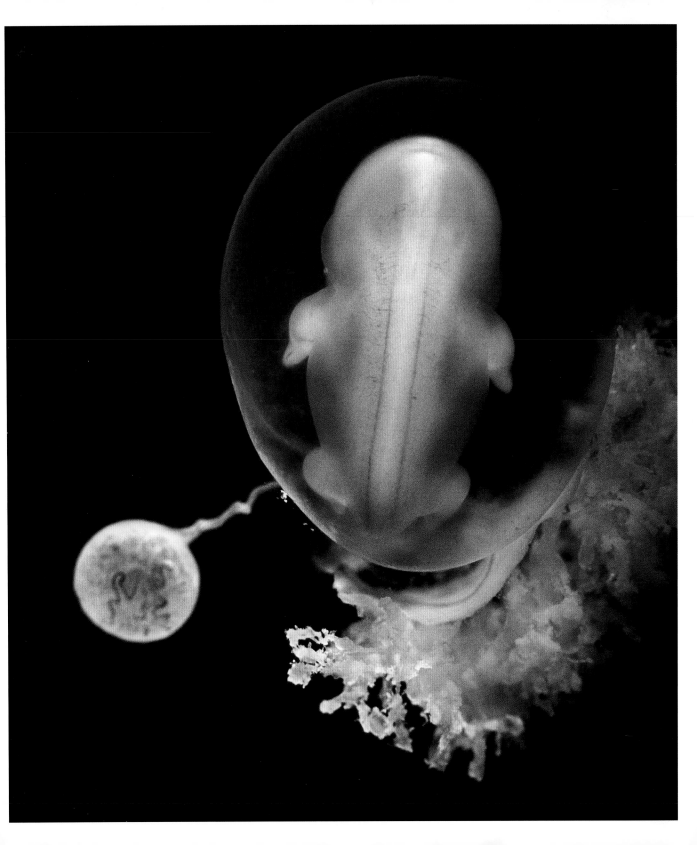

7 weeks The heart of the embryo beats 140–150 times per minute.

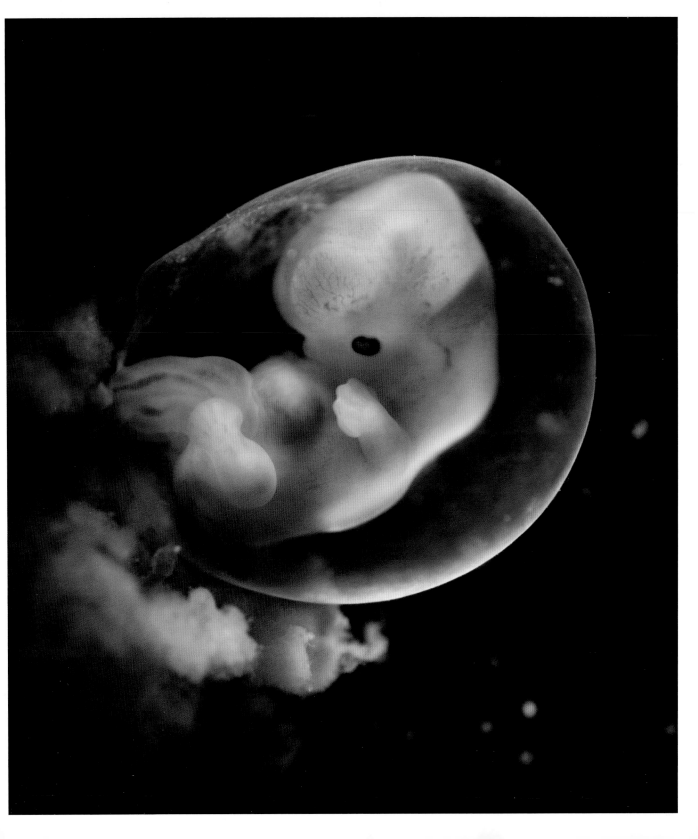

8 weeks The rapidly-growing embryo is well protected in the foetal sac.

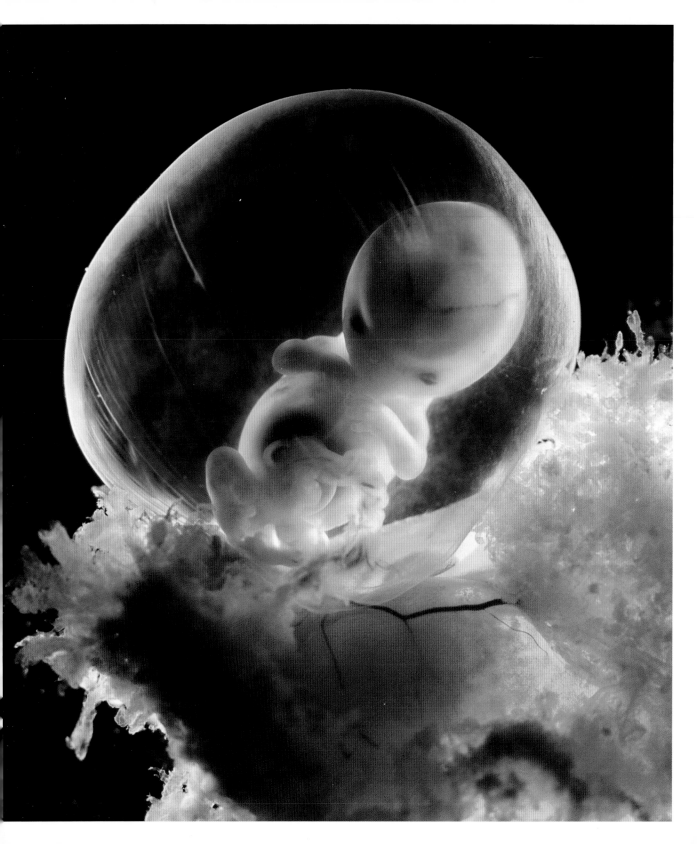

9 weeks Large numbers of V-shaped blood vessels are developing where the skull bones are fusing.

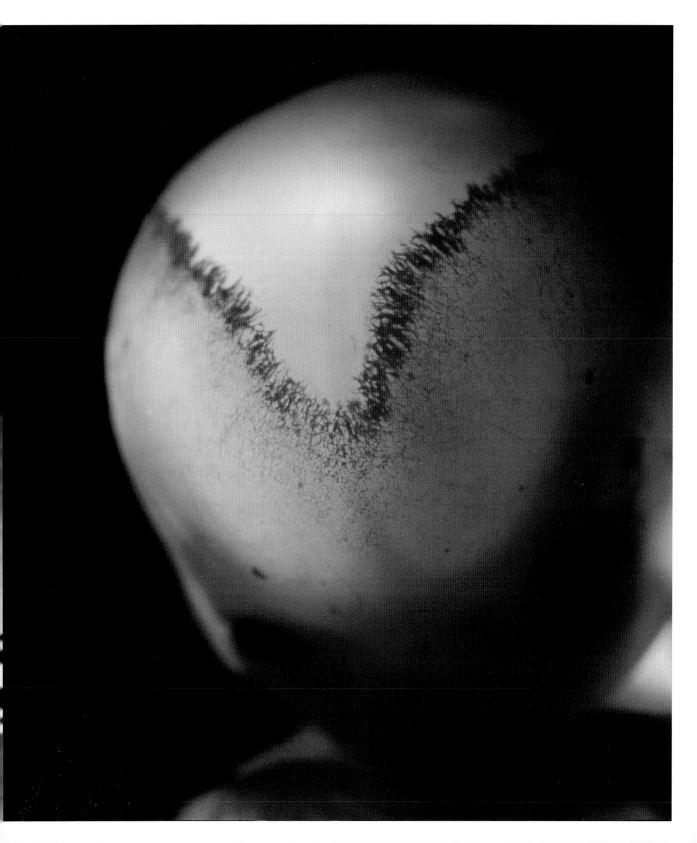

Nerve cells in a complex network with multiple functions.

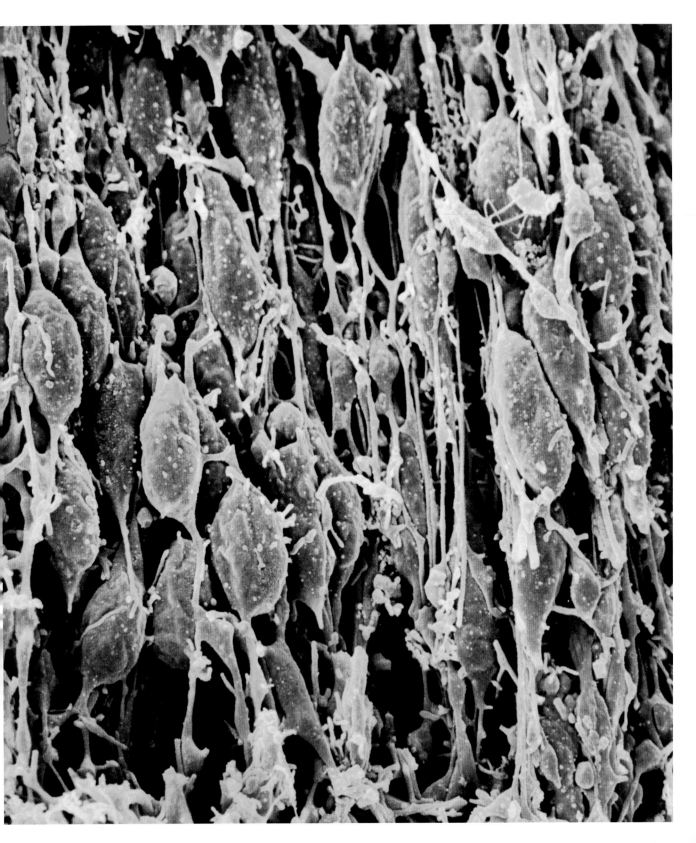

10 weeks Approximately 30 mm. The embryo enters the foetal stage.

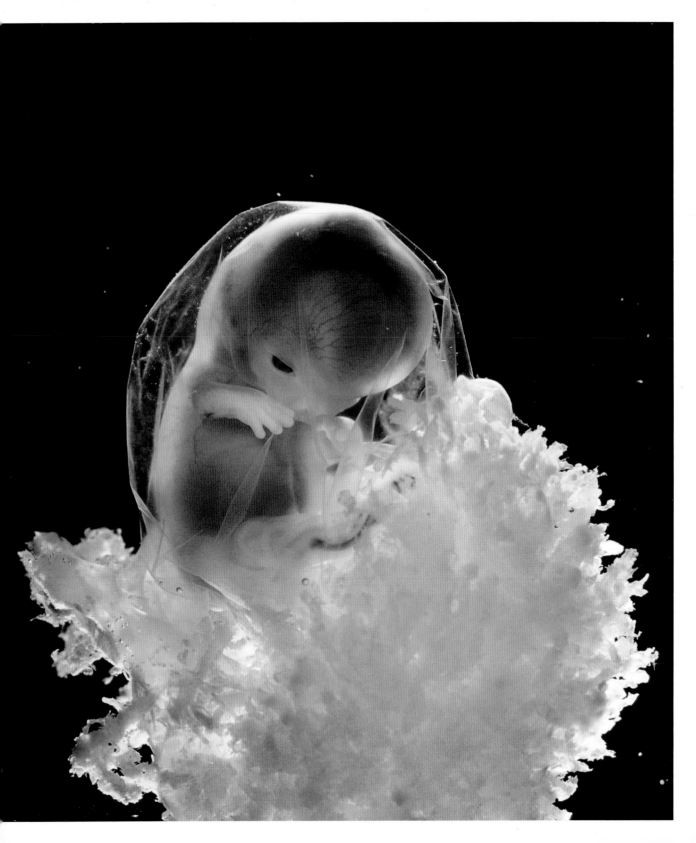

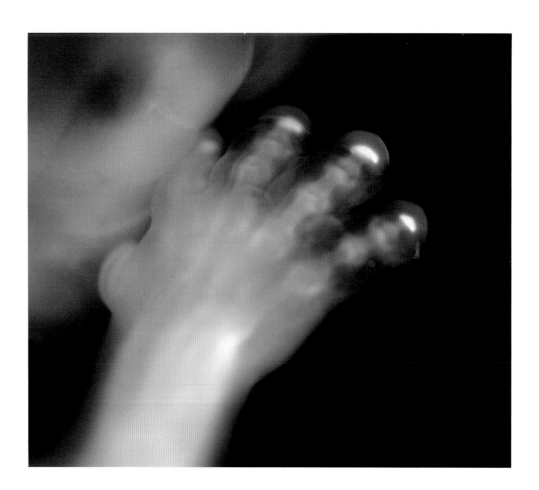

The cartilage skeleton is visible through the thin tissue.

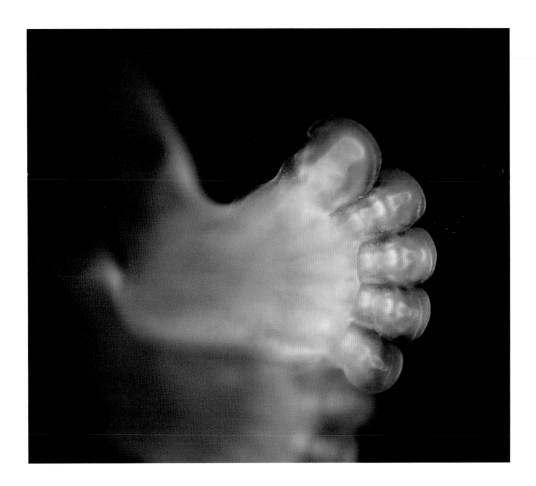

The development of the feet progresses more slowly than that of the hands.

The eyelids are semi-shut. They will close completely in a few days.

PAGE 160 11–12 weeks. The foetus, backgrounded by the placenta. The yolk sac, to the left, is no longer needed.

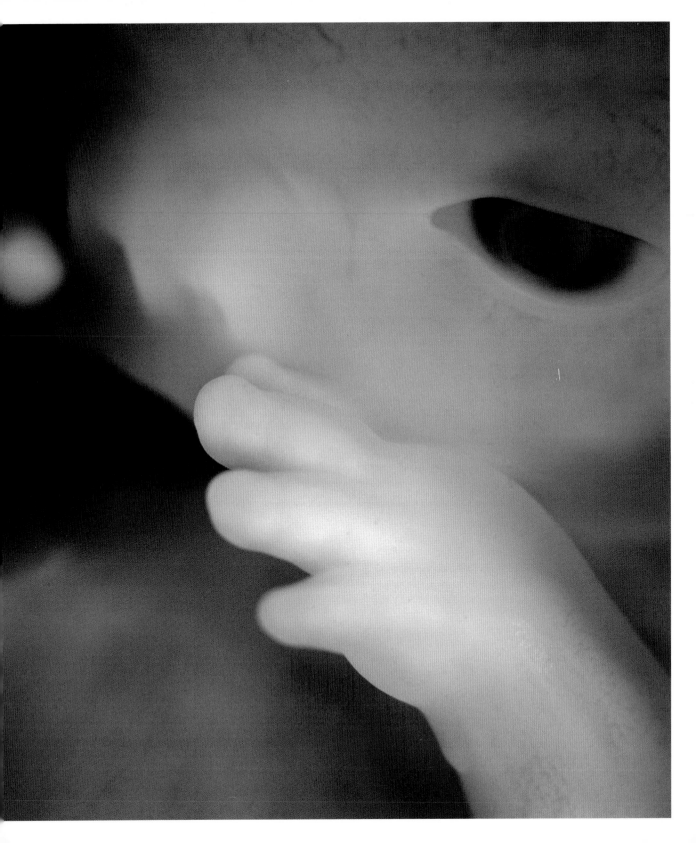

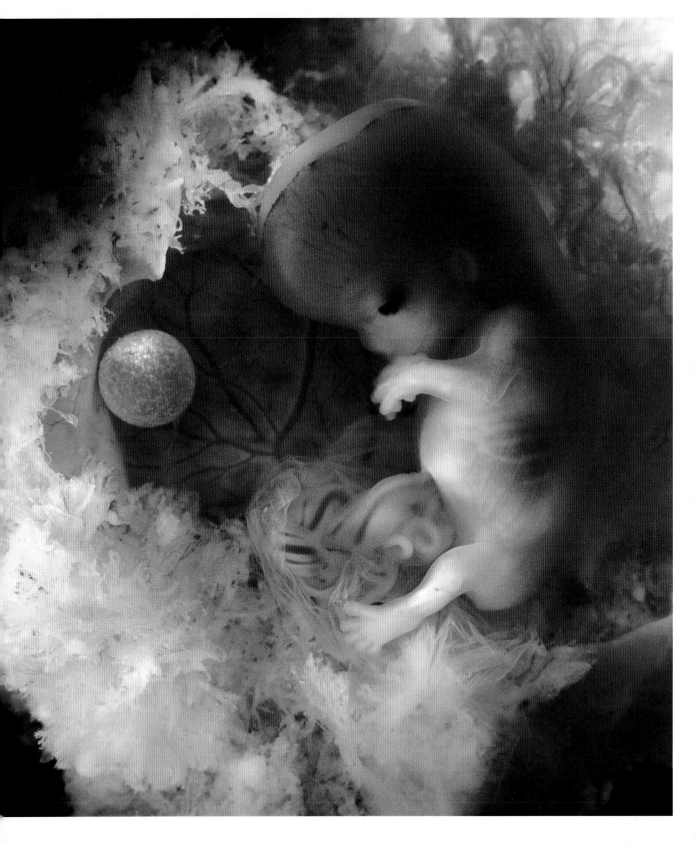

13 weeks A suggestion of incipient bones in the tubes of the arms.

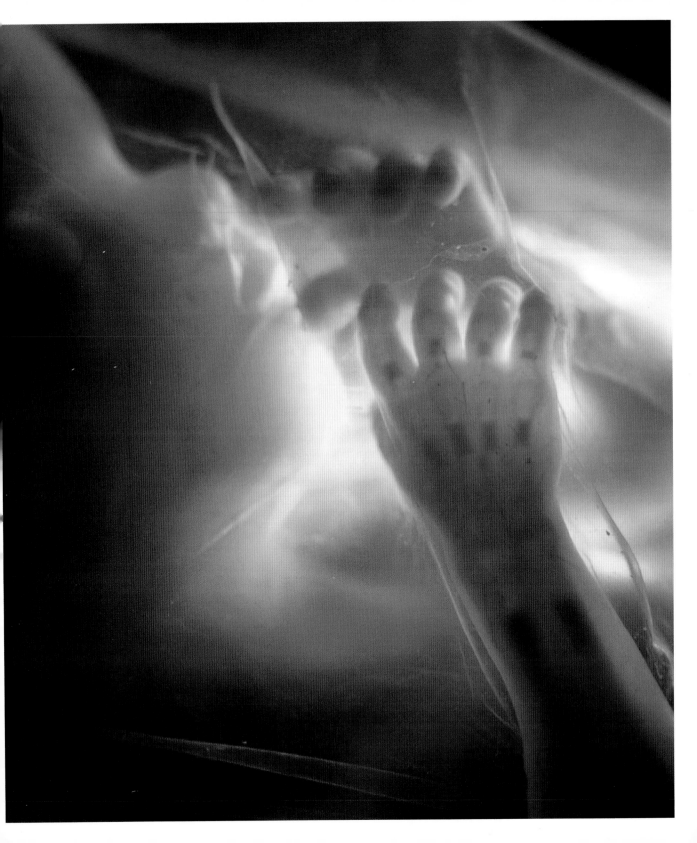

16 weeks The foetal movements become increasingly strong and purposeful.

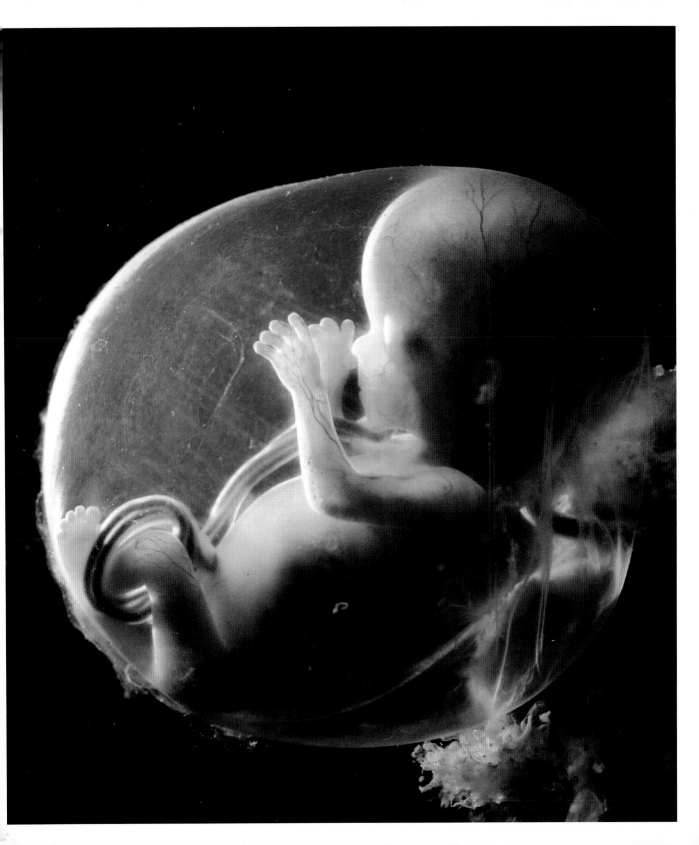

The foetus uses its hands to explore its own body and its surroundings.

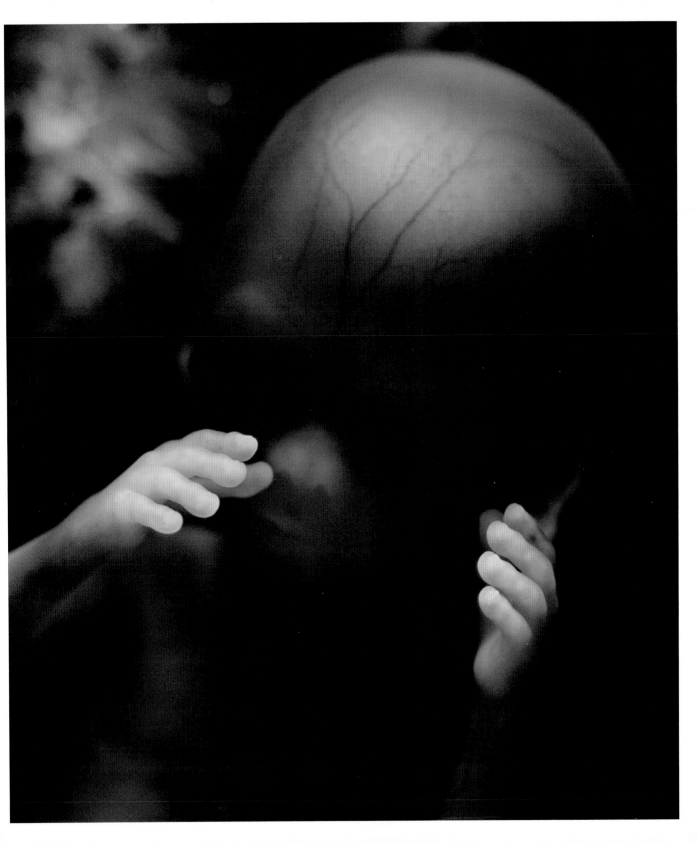

The network of blood vessels for arm and hand, visible through the thin skin.

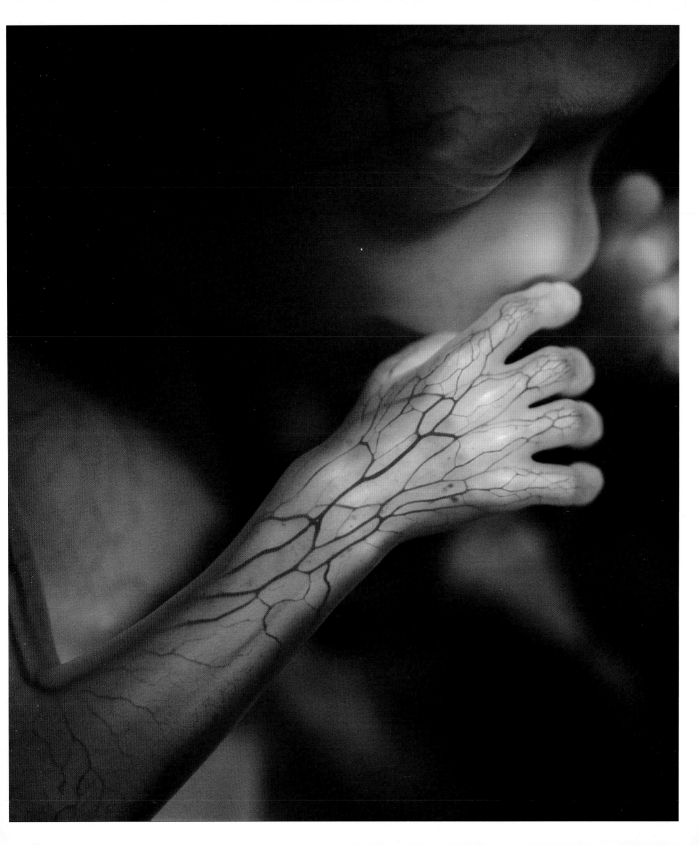

The foetus can now grab and pull the long umbilical cord. The skeleton consists mainly of flexible cartilage.

PAGE 172 Millions of red blood corpuscles are gathered in the capillary vessels of the placenta.

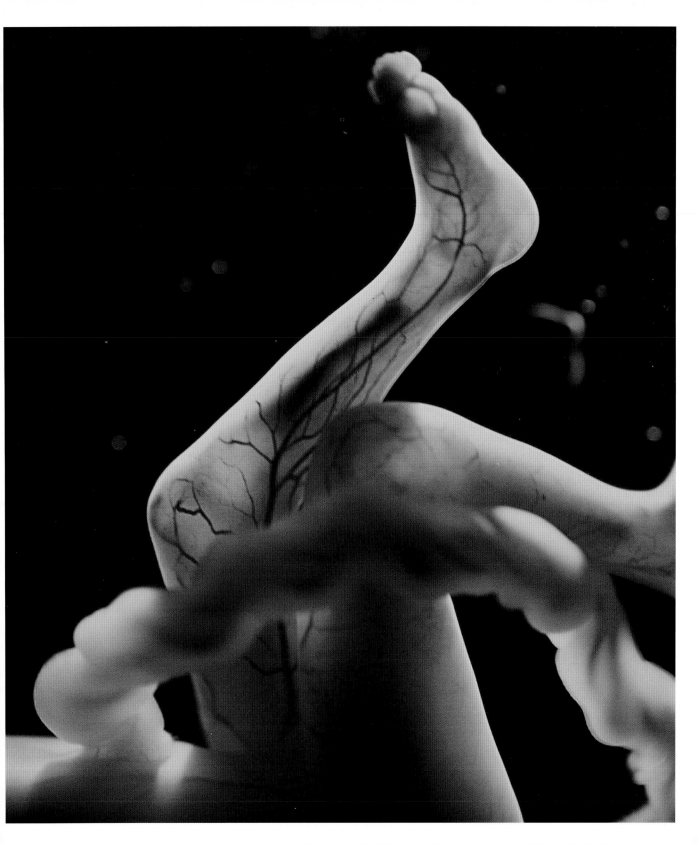

17 weeks approximately 12 cm.

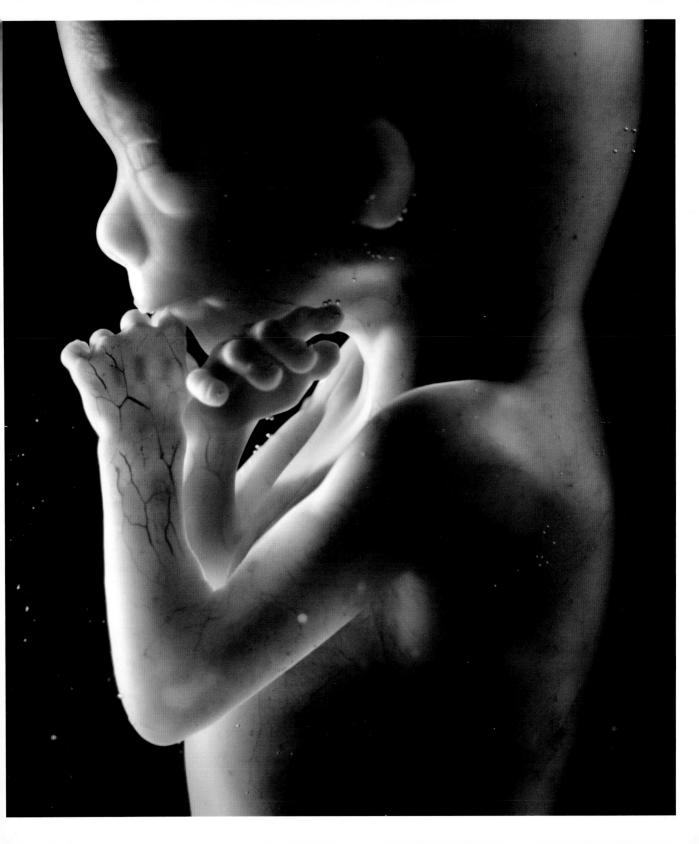

20 weeks approximately 20 cm.

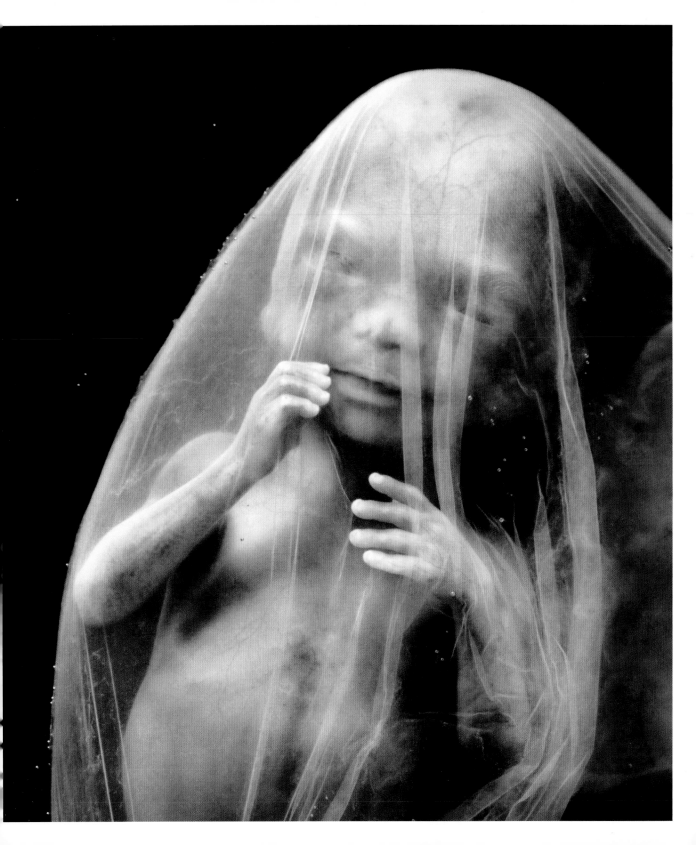

Woolly hair, lanugo, covers the entire head.

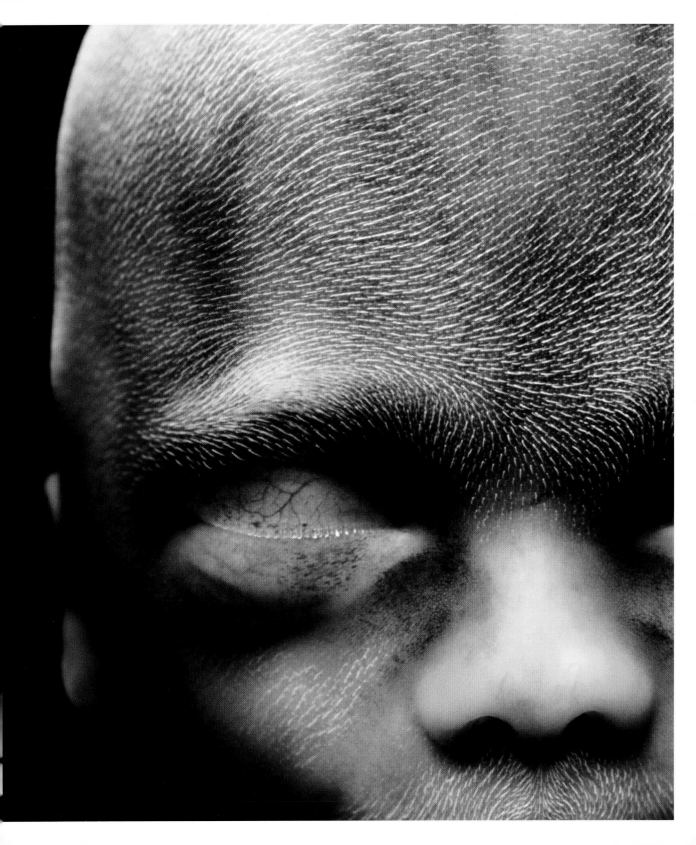

A swirl of hair on the forehead. The fine lanugo hair follows the same pattern on the skin as does the hair on the foetus' head.

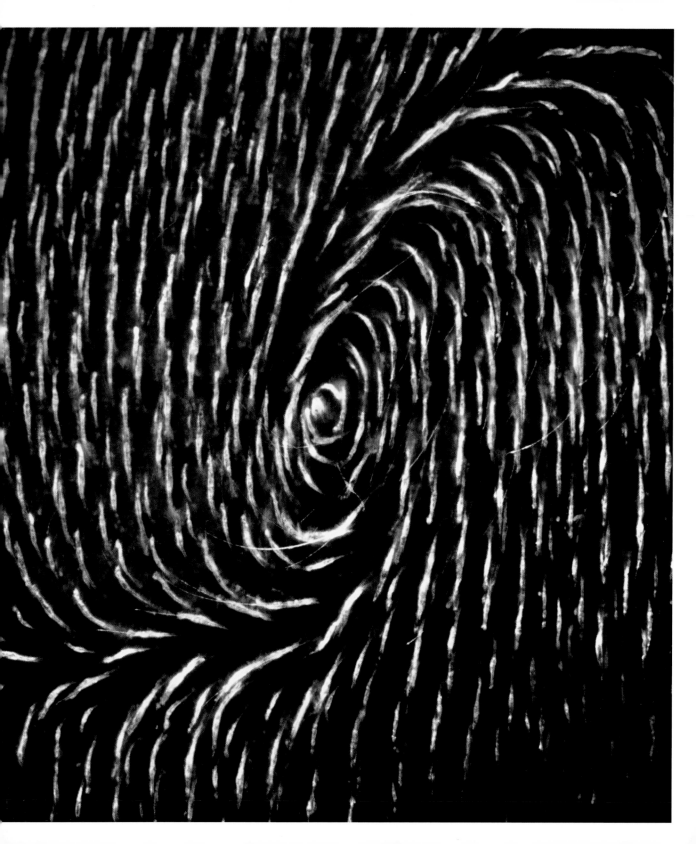

A swirl of hair on the neck.

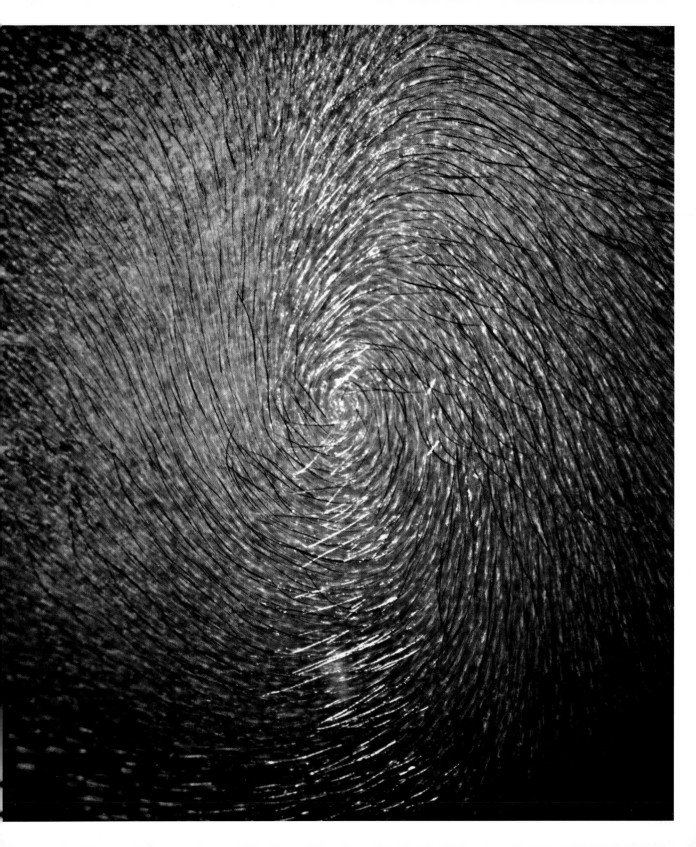

23 **weeks** approximately 30 cm.

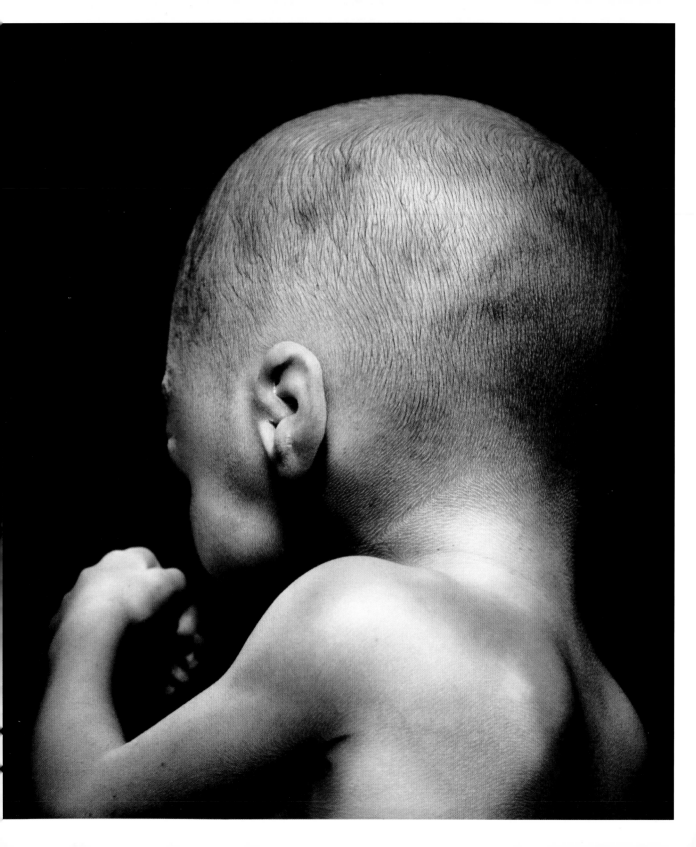

17 weeks The eyes are shut and will not open again until week twenty-six.

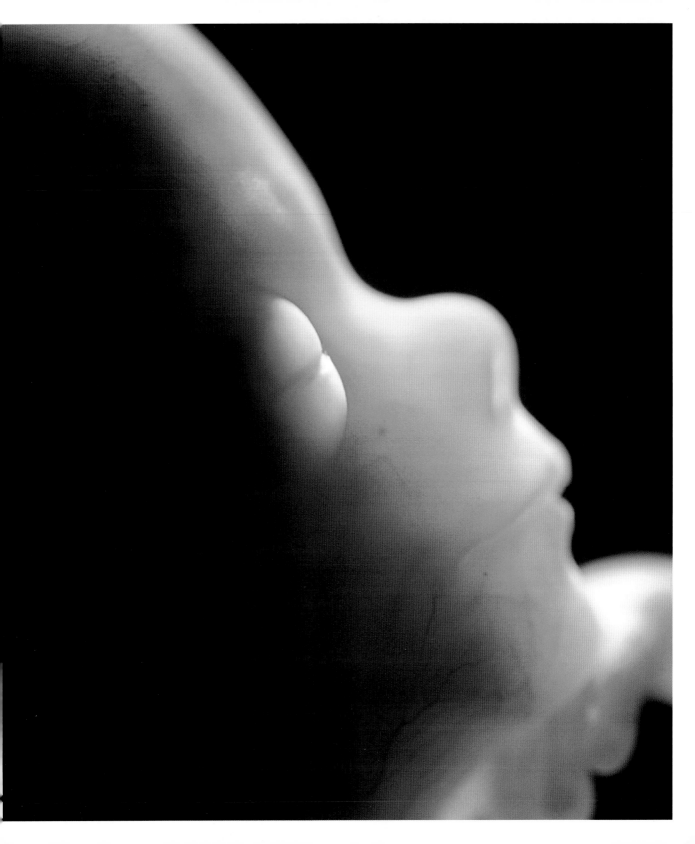

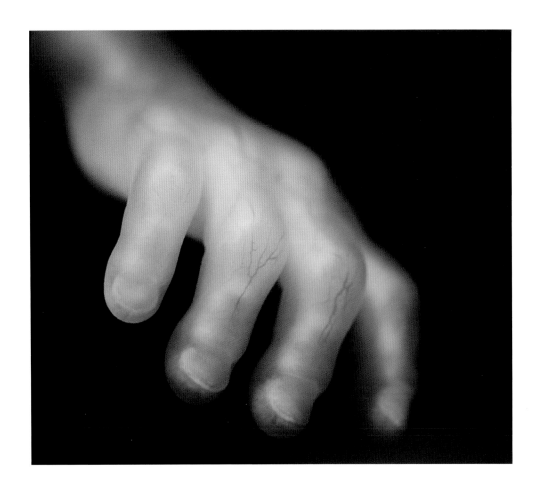

The hand now has fingernails.

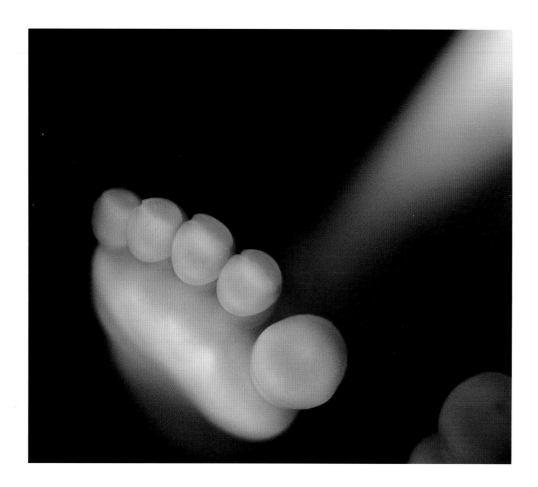

The bone tissue in the foot begins to calcify.

18 weeks Approximately 14 cm. The foetus can now perceive sounds from the outside world.

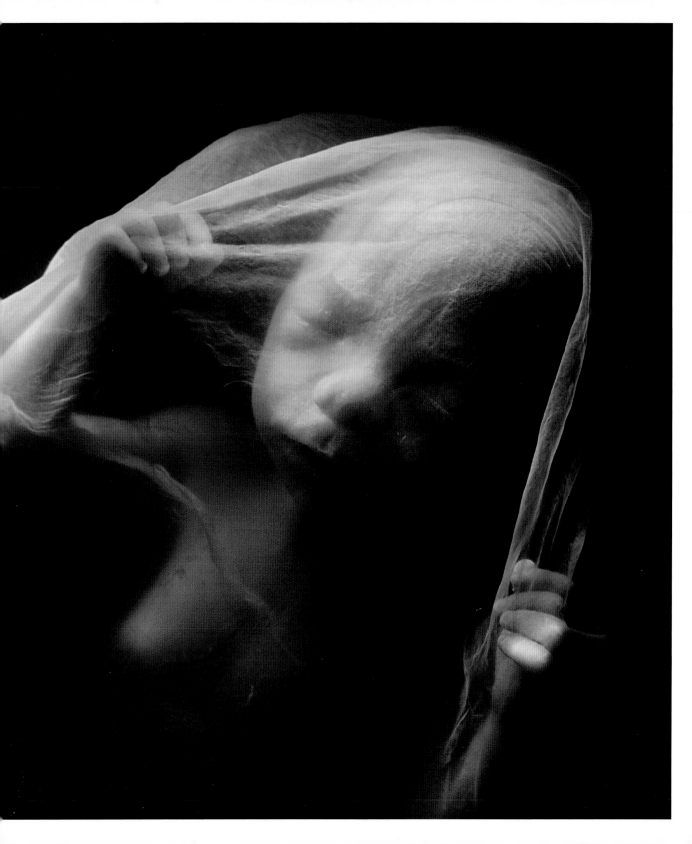

20 weeks The sucking reflex is triggered when a thumb approaches the mouth.

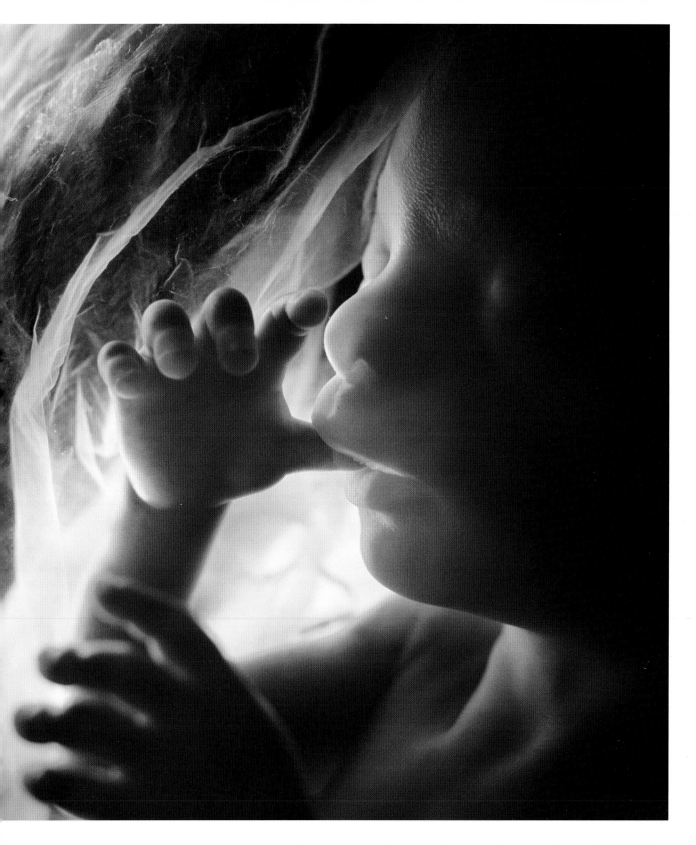

24 weeks Approximately 30 cm. The foetus weighs just over one pound.

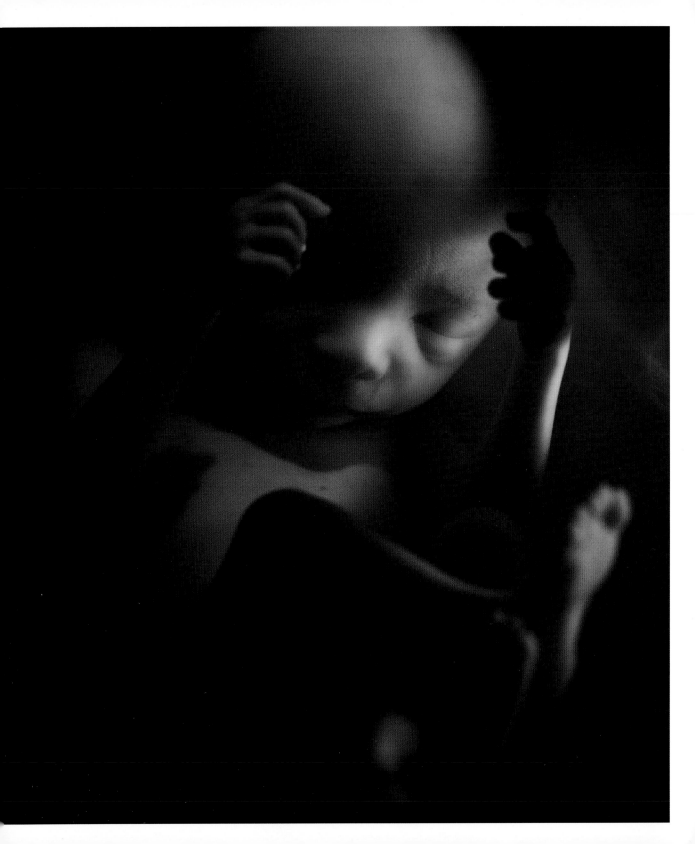

26 weeks The uterus is still fairly spacious.

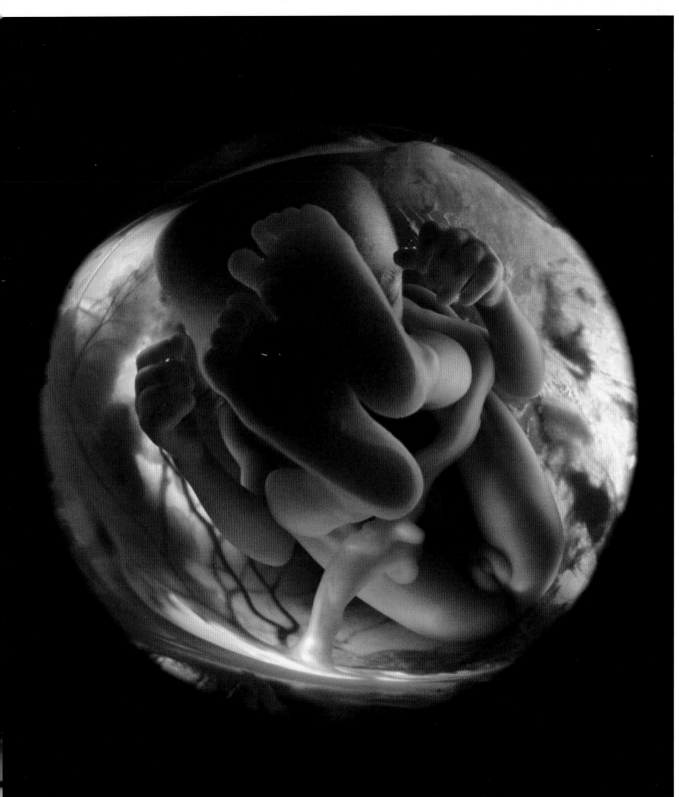

31 weeks The foetus is slim, but during the remaining weeks it will put on more and more subcutaneous fat.

PAGE 200 36 weeks. The uterus is becoming a tight fit.

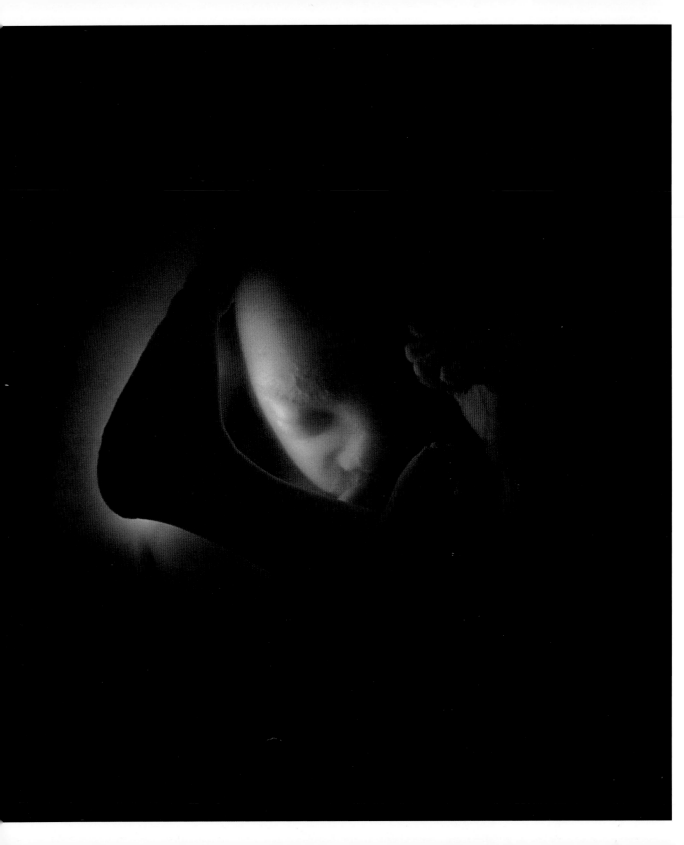

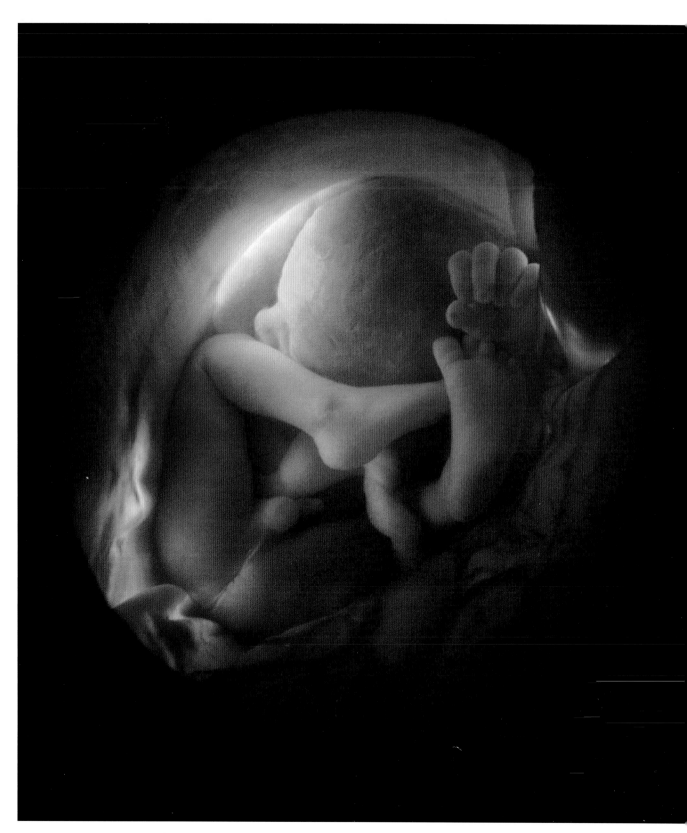

Pregnancy

THE PREGNANCY TIMELINE. A woman with regular menstrual periods ovulates approximately fourteen days after the first day of her period, and if the egg is fertilised, just over a week later the embryo will have implanted itself into the uterine lining. Once this has happened, the woman is pregnant. The pregnancy timeline is usually measured not from the date of ovulation, but from the first day of the woman's last period. On this timeline a pregnancy lasts forty weeks, in spite of the fact that in a full-term pregnancy the embryo will spend only thirty-eight weeks in the mother's Fallopian tube and uterus. Here we use the terms "weeks" and "days". Weeks refer to the week of pregnancy, while days refer to the actual age of the embryo from the day of fertilisation.

Early signs of pregnancy are brought about by changes in the woman's hormone balance, not by the new coagulation of cells in her uterus. One important substance governing the changes in the body of a pregnant woman is the production of a hormone, human chorionic gonadotrophin (hCG). This hormone is created by the placenta cells and, via the bloodstream, signals to the ovaries and the pituitary gland that there will be no need for ovulation for some time because the woman is pregnant. The corpus luteum in the ovary also responds to these signals by creating more progesterone, needed for the uterus to provide the embryo a good environment to grow in.

PAGE 122

Just over a week after implantation, the formless clump of cells becomes an oblong little being, almost resembling a worm. The embryo's superficial layer of cells begins to thicken around the midline of the body, forming two lengthwise folds. These cells are called the outermost germ layer. Between these folds an indentation deepens, then quickly closes, making a tube. At one end the primitive brain begins to form, and nerve fibres begin to protrude from the brain stem. On day fifteen in the life of the embryo the first primitive brain cells are formed.

PAGE 124

PAGE 126

In addition to the outermost germ layer, which will go on to become the brain, spinal cord and nerves, as well as skin, hair sebaceous glands and sweat glands, there are two other germ layers. The middle germ layer will develop into the skeleton, the heart muscle wall, and the other muscles. The middle layer also becomes blood vessels and lymphatic vessels. The ovaries and testicles as well as the kidneys also come from this layer. The inner germ layer will give rise to the intestinal system, stomach and the urinary tract, as well as all the cells in the mucous membranes of the body.

The heart is one of the organs that begins to develop very early, and on the twenty-second day of the embryo's existence the heart muscles contract, and the heart beats for the very first time. These muscle cell contractions spread mechanically to surrounding cells, rather than via nerve impulses as later in the development process. The mission for the heart is the circulation of blood, through which nutrition and oxygen are distributed to all the developing organs. Early in the body's development, the heart is large and almost seems to be outside the rest of the body. The right-hand chamber takes up the blood from all the other organs, and the left-hand chamber releases freshly oxygenated blood to the body.

PAGE 130

PAGE 132

The blood of the embryo is not yet oxygenated via the lungs as it will be after birth. During pregnancy the foetus' blood is oxygenated via the mother's circulatory system, in the vast, branching vascular system of the placenta. Immediately after implantation, this system spreads out to cover more and more of the uterine wall. Between the placenta and the embryo runs the umbilical cord, which contains three vessels: one thick vessel that carries oxygenated blood and nutrients to the embryo, and two narrower vessels that carry oxygen-poor blood containing waste-products from the embryo back to the mother's circulatory system. The circulatory systems of the embryo and the mother remain separate throughout the pregnancy. This separation protects the embryo, as it develops, from some substances, which do not pass

PAGE 138

through the filter of the placenta. Normally, neither bacteria nor viruses pass through the placental barrier, which makes the separation important, because the embryo does not yet have a well-developed immune system.

A face begins to develop as early as the end of week five, at which point it is possible to distinguish both a nose and a mouth. The skeletal parts of the face, the lower jaw and the neck develop from shoots on the vertebral column. It is clear from a very early stage that human beings are vertebrates. On both sides of the backbone, a number of skeletal building blocks form from the middle germ layer. These develop into thirty-three or thirty-four vertebrae. Below the cervical vertebrae, twelve thoracic vertebrae develop, from which the ribs grow, to form the chest. Inside this cavity there are already primitive lungs. PAGE 142 PAGE 144

From the little hollows between the vertebrae, bundles of nerves spread from the spinal marrow. This delicate network of nerves then spreads through the body, and comes to play two very different but complementary functions. The brain and the spinal cord will emit signals to all the muscles in the body, instructing them to contract and perform various motions. The embryo can now make lively little global motions affecting the whole body. This constant motion is an important aspect of growth and development. Gradually more and more information will be returned to the brain so that it will know what the rest of the body is doing. Some nerves will register sensation, others pressure and temperature. Special nerve impulses will later in the development of the foetus be sent to the brain from the eyes, ears, and nose, while the mouth will transmit taste impulses.

In the eighth week of pregnancy the embryo grows very fast, doubling in size in just one week. Having looked until now like almost any primitive mammal, the embryo begins to look more like a miniature human being. The head, hitherto tipped forward, PAGE 148

straightens up. In terms of size, the head is still dominant, and the upper body is much larger than the lower body. The arms and hands have developed further than the legs and feet, but there is only a suggestion of fingers.

The genitals of both girls and boys begin to develop in week eight to nine. A little bud develops between the legs of the embryo, irrespective of sex. In girls it develops into the clitoris, and in boys into the penis. Gradually two little bulwarks take shape on either side of a crack. In a boy they merge to become the scrotum, while in a girl they structure the vaginal walls, and the crack will not fuse shut.

The embryo becomes a foetus at the beginning of week ten of the pregnancy, fifty-six days after fertilisation. The foetus is still growing rapidly. The uterus is the size of a man's fist. A month from now it will double in size. Many of the organs have already begun to function: the kidneys produce urine and the stomach produces gastric juice. The yolk sac, which supplied the embryo with nutrients and produced primitive blood vessels during the first weeks of life, has now served its function, and other organs have taken over. The coordination of the organ system has only just begun, but the most sensitive stage of the pregnancy has now been successfully completed. After week twelve of pregnancy, miscarriage is quite uncommon.

PAGE 154

The lens system of the eyes develops early, and the eyes react to light beginning in week ten. In week twelve it is possible to discern eyelids that close the eyes. They will not open again until week twenty-six, but the visual cortex and the vision centre of the brain continue to develop. However, life in the uterus does not require a highly developed sense of vision. The development of the ears is very similar to that of the eyes. The inner and middle ears develop early, while the final form of the outer ear is not complete until week twenty. In addition to hearing, the ears are also responsible for our sense of balance.

PAGE 158

In week thirteen of pregnancy the foetus moves more and more, and the jerky body motions are replaced by slower and apparently more purposeful ones. The hands find their way to the mouth, and some of the movements of the foetus resemble breathing or yawning. Initially, the foetus never seems to sleep for more than a few minutes at a time, while later in pregnancy there is a more regular day-and-night rhythm, with extended periods of sleep.

The soft, supple body becomes more stable as some of the cartilage begins to turn to bone. The calcification process begins in the long arm and leg bones, and even the skull bone begins to calcify early to better protect the sensitive brain.

PAGE 162

The foetus is encapsulated in the amniotic sac, filled with liquid that is exactly normal body temperature. As the amount of amniotic fluid increases, the growing foetus gets greater freedom of movement. In the foetal stage, we are thus well-adapted to an aqueous life. This also applies to foetal skin, which is protected by a salve, the vernix caseosa. The first primitive hair develops in week twelve, a kind of woolly hair, lanugo, that covers the whole body. Beginning in week sixteen, the roots of the hair on the head and in the eyebrows become a little thicker and more distinct, with clear elements of pigment. The lanugo falls away before birth, but some of the protective vernix remains, so a newborn usually feels slick and a little sticky.

PAGE 164

PAGE 178

The womb is still spacious, and the foetus is in constant motion. In spite of being surrounded by the amniotic sac and the uterine lining, the foetus does not live in a world of silence. Beginning in weeks eighteen or twenty, the foetus can perceive sounds from the outside world. The foetus often grips the umbilical cord, and when a thumb approaches the mouth the sucking reflex is triggered. Practising this reflex is, of course, important preparation for nursing.

PAGE 192

In week twenty-five of the pregnancy, an important line of demarcation has been passed. The foetus has now accomplished so much development that it has a good chance of survival outside the womb, with the full spectrum of neonatal resources implemented. But usually the foetus continues to grow and develop in the uterus for over three more months. Over time the room for manœuvre decreases markedly, but the foetus can still turn around.

PAGE 196

The foetus is still slim, but gains about 200 grams each week. Although the organs are maturing steadily, the very important lungs are not prepared to fulfil their function, so essential to life, until quite late in the pregnancy. At this point the heartbeat is very rapid, 140–180 beats per minute, nearly twice that of the mother's. The kidneys are fully operational, and the urine mixes with the amniotic fluid, the amount of which constantly increases. Arms and legs are now exercised with increasing frequency and coordination. The eyes of the foetus can now clearly perceive light impulses. Sensitivity to sound also increases.

PAGE 198

During the last month, the foetus descends further into the pelvis; ninety-five per cent of foetuses are now positioned head first, and most with their face to their mother's back. Sometimes babies are born seat or feet first, which does not usually pose major problems.

PAGE 200

Delivery generally takes place between weeks thirty-eight and forty-two. Hard kicking may trigger the labour process, but usually the decisive factor is a shift in the mother's hormonal function. Throughout the pregnancy, progesterone levels in the placenta have increased. It is progesterone that mainly accounts for keeping the uterine musculature relaxed and smooth. Towards the end of pregnancy, a breaking point is reached, and the placenta begins to produce less progesterone. This, in combination with the pro-

duction of increasing amounts of other hormones – oxytocin, prostaglandin and cortisone, all of which cause the uterus to contract, is a clear signal to the body that it is time to go into labour.

Three signs tend to indicate that the labour is at hand: regular contractions of the uterine muscles, the amniotic fluid running out of the vagina, and bloody, quite heavy discharges. Sometimes labour begins when the amniotic fluid runs out with no previous contractions.

Labour is divided into three stages, of which the first is called the opening stage. During this stage, contractions are regular, at several minute intervals. The cervix dilates gradually until it has opened to 10 centimetres. When it is fully dilated the baby's head (or seat) descends toward the mother's pelvic floor. This is the beginning of the second stage of labour, the expulsion stage. The contractions become even more intensive, and are called bearing down pains.

The moment when the child is born and the umbilical cord is cut is an indescribably critical time. It is when the baby's lungs undergo their very first test; can they oxygenate the blood? The baby's first cry draws air into the pulmonary cavities, and the crying and coughing reflexes release mucous from the upper respiratory tract. Now all that remains is the afterbirth stage, when the foetal sac and placenta are discharged from the uterus, exiting by the same route as the baby. A child is born.

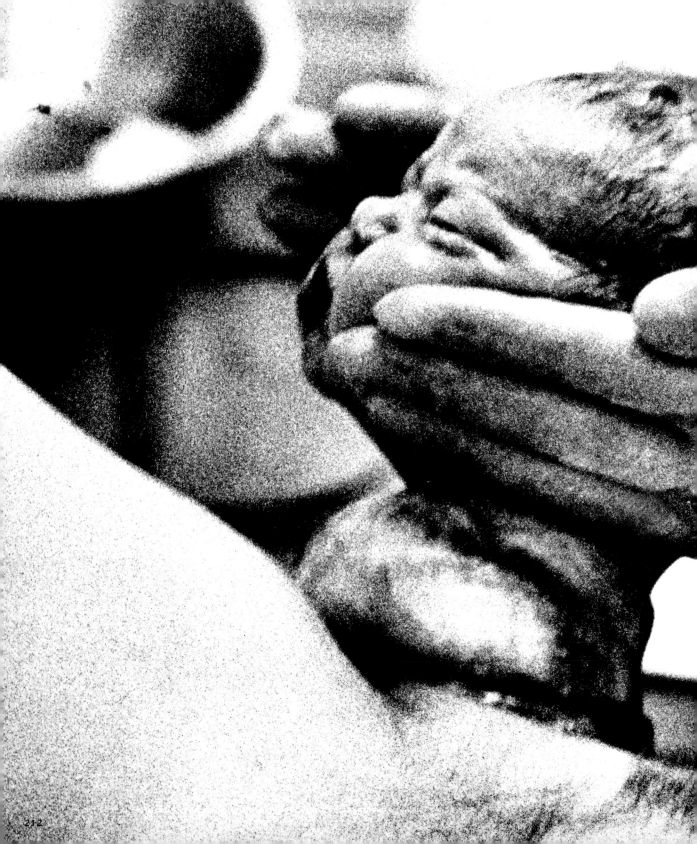

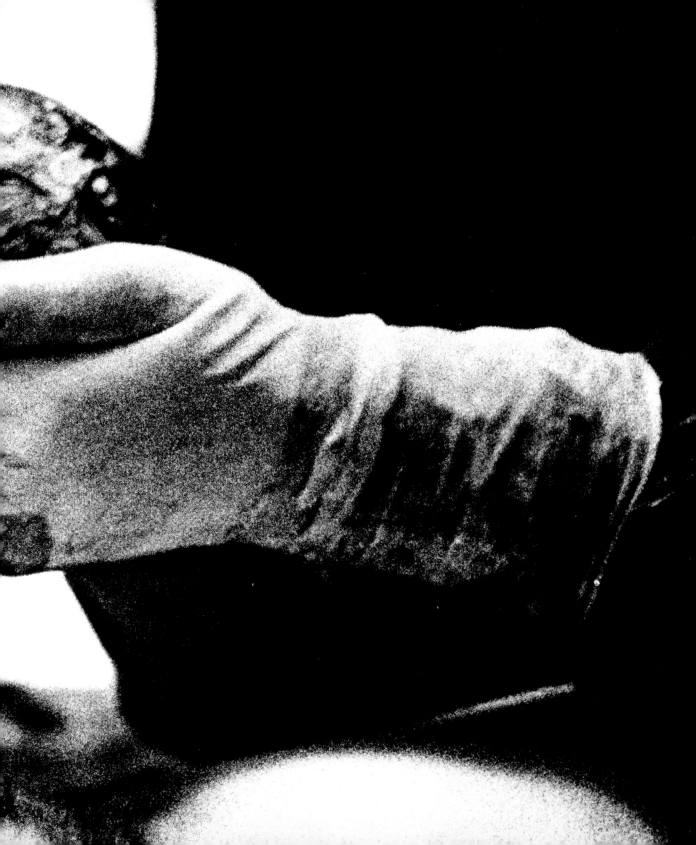

A Child is Born

Technical background

MANY OF LENNART NILSSON'S PHOTOGRAPHS in this book were made by conventional photography using Hasselblad and Nikon cameras with macro and other special lenses. However his photographs have changed with the development of optical technology in the years since the first publication of *A Child is Born*.

His first photographs inside the human uterus were possible with the use of the endoscope. He made a picture of the legs, hands, feet and sex organs of a foetus in 1957. At that time the endoscope was capable of making a relatively sharp image of a limited area of the subject. Since then there have been many advances. After working for more than twenty-five years with the Storz optical company in Germany he can use a flexible endoscope with a diameter of only 0.6 mm. He is able to use a super wide-angle lens with a scope of 170 degrees. The lens can be as small as 0.5 mm in diameter. Today the use of the endoscope is possible on occasions when doctors are investigating genes by means of amniocentesis.

The scanning electron microscope enabled him to make photographs with a magnification of hundreds of thousands of times. These images have a greater sense of depth or three-dimensionality and sharpness than those obtained by conventional light microscopy. The photographs were made using black and white film that was then specially converted to colour with a technique based on translation of the grey scale. Some of the scanning electron microscope imagery has been digitally tinted.

Ultrasound technology is in common use for studying foetal development. It is easy to administer, has three-dimensionality and its quality is progressing rapidly. Lennart Nilsson is using this technology, though such pictures are not included here. His classic photographs were made before the technology was available. Even though it is questionable whether the technology at this point would produce images that were clearly identifiable as the work of any individual photographer, Lennart Nilsson is consciously making photographic compositions with ultrasound.

Acknowledgments

A Child is Born has a long history and has appeared in many different editions around the world. The whole enterprise has been an act of collaboration and my debts are many.

The book began with my work at the Women's Clinic of the Sabbatsberg Hospital in Stockholm in the 1950s. There I received the support of Professor Axel Ingelman-Sundberg, Mirjam Furuhjelm, Erik Odeblad, Björn Westin and others.

Over the years I have received enormous help from staff at the Danderyd Hospital, the Karolinska University Hospital, the Söder Hospital and St Erik's Hospital in Stockholm, Sahlgrenska University Hospital in Gothenburg, and Rigshospitalet in Copenhagen.

Throughout my later career Karolinska Institutet has been the centre of my work and I am greatly indebted to Margareta Almling, Jan Lindberg and Hans Wigzell.

Gillis Häägg has been my constant support with his unique colouring techniques and extraordinary prints.

The scans for this new edition have been prepared by Lennart Damgren of Förstorings-ateljén and wonderful new black and white prints have been made by Helena Påls.

As technology has evolved I have been fortunate to receive from Germany the expertise of Karl Storz GmbH KG for the endoscopes and Carl Zeiss for the light microscopes. From Japan I received the JEOL Scanning Electron Microscope. In Stockholm I have received technical equipment developed by Werner Donne and Lorentzén Instrument AB.

So many people over the years at Bonniers have patiently prepared and supported the publication of these books, but I should especially thank Jan Cornell, Barbro Dal, Per Wivall, Sara Nyström, Robert Hedberg, Susanna Eriksson Lundqvist and Gunilla Hedesund.

I am especially grateful to Axel Ingelman-Sundberg, Mirjam Furuhjelm and Claes Wirsén for the texts for the first and second editions and to Lars Hamberger for the texts for subsequent editions.

The ongoing work of Lennart Nilsson Photography has been organised with great commitment by Anne Fjellström. The new approach of the fifth edition is the result of the sensitive editorial guidance of Mark Holborn.

Above all, I must thank the numerous parents and their children, nurses and midwives who over the years have allowed me to be present at moments of huge importance in their lives. Without them none of this would have been possible.

Lennart Nilsson
Stockholm 2009

EDITOR Mark Holborn LENNART NILSSON PHOTOGRAPHY Anne Fjellström DESIGN Nina Ulmaja

Published by Jonathan Cape
2 4 6 8 10 9 7 5 3 1

PHOTOGRAPHY COPYRIGHT 2009 © Lennart Nilsson Photography AB
TEXT COPYRIGHT 2009 © IN VITRO AB, Lars Hamberger
TEXT COPYRIGHT 2009 © Mark Holborn (Introduction and Chronology of a Book)
TEXT COPYRIGHT 2009 © Bonnier Fakta AB (Technical background)

ORIGINALLY PUBLISHED IN SWEDEN UNDER THE TITLE
Ett barn blir till by Bonnier Fakta AB, 2009

TRANSLATED FROM SWEDISH by Linda Schenck
PHOTOS ON PAGES 219–223, 225 by Caroline Andersson

FIRST PUBLISHED IN GREAT BRITAIN IN 2009 BY
Jonathan Cape
Random House
20 Vauxhall Bridge Road
London SW1V 2SA

www.rbooks.co.uk

Addresses for companies within The Random House Group Limited can be found at:
www.randomhouse.co.uk/offices.htm

The Random House Group Limited Reg. No. 954009

A CIP catalogue record for this book
is available from the British Library

ISBN 9780224089951 (LARGE FORMAT EDITION)
ISBN 9780224089944 (HARDBACK EDITION)

The Random House Group Limited makes every effort to ensure that the papers used in its books are
made from trees that have been legally sourced from well-managed and credibly certified forests.
Our paper procurement policy can be found at: www.randomhouse.co.uk/paper.htm

PRINTED AND BOUND IN ITALY BY
Printer Trento S.r.L.